IMAGES
of America

GREENEVILLE

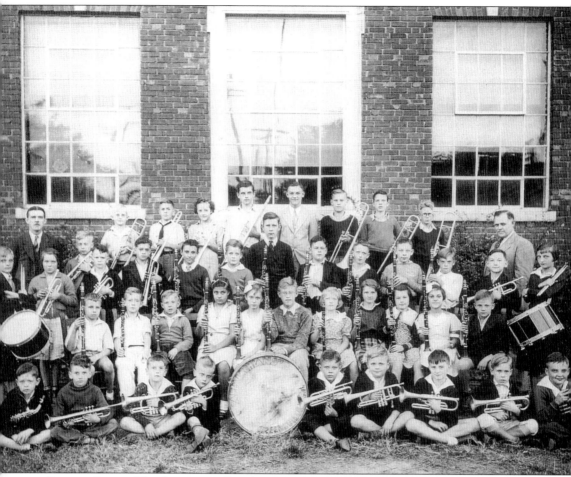

ON THE COVER: This fine group of band students from the Crescent School gathered for picture day in the early 1920s. Pictured here from left to right are (first row) A. C. Broyles Jr., unidentified, Charles Hankins, ? Fenstemacher, Herbert Lamons, Joe Hendron, Phil Hawkins, Lloyd Ricker, and Robert Craft; (second row) Bobby Cochrann, Ralph Renner Jr., unidentified, Christine Stevens, ? Bracken, Everett "Fuzzy" Morrow, Betsey Bowman, Dorothy Jean Wayland, Mary Simpson, Virginia Shadeed, and Ben Russell; (third row) Ralph Fenstemacher Jr., Elizabeth Reaves, Loye Chase, Billy Rudder, Ray Aiken, Robert Williams, Bob Deaver Daves, Carroll McInturff, Jack Fry, O. D. Cagle Jr., Hubert Kilday, Junior Wright, Earl Snapp Jr., and Joanne Farnsworth; (fourth row) band director Clint Walker, Glen McDonald, Donald Morgan, Maxine Renner, ? Cunningham, Willis Johnson, Guy Boswell Jr., Eugene Wampler, Sammy Thacker, and principal S. T. Gass. (Courtesy of Maxine Renner Russell.)

IMAGES
of America

GREENEVILLE

Matilda B. Green

ARCADIA
PUBLISHING

Copyright © 2006 by Matilda B. Green
ISBN 0-7385-4279-2

Published by Arcadia Publishing
Charleston SC, Chicago IL, Portsmouth NH, San Francisco CA

Printed in the United States of America

Library of Congress Catalog Card Number: 2006923087

For all general information contact Arcadia Publishing at:
Telephone 843-853-2070
Fax 843-853-0044
E-mail sales@arcadiapublishing.com
For customer service and orders:
Toll-Free 1-888-313-2665

Visit us on the Internet at www.arcadiapublishing.com

*For my children, Elizabeth and Frank,
and my mom, Matilda, because I love them.
In memory of my father, Elba, my grandmother Elizabeth,
and my husband, Thomas.*

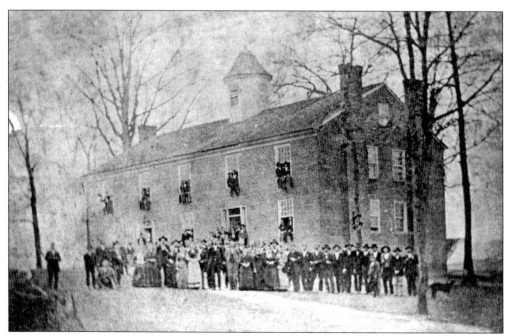

Tusculum College as it appeared in 1875 was the scene for this group photograph. Notice the students posing in all the windows. (Courtesy of Mr. and Mrs. Robert Smith.)

CONTENTS

ACKNOWLEDGMENTS

My sincere appreciation goes out to so many friends and acquaintances that helped with the collection of information and photographs for this book. Thanks to John Hendrix, director of the Nathanael Greene Museum, for his courteous and professional assistance. His knowledge of the community and organization of materials was invaluable. I am also grateful for the availability of materials at the Greeneville–Greene County Public Library, including the T. Elmer Cox Historical and Genealogical Library.

Thanks go to Maggie Bullwinkel, acquisitions editor at Arcadia Publishing, for her support, kindness, and, above all, her patience. She has been a real gem.

I would like to thank Larry Buttram, author of *False Witness* and *Honor Thy Sister*, for encouraging me to take on this task; Eleanor Mosca, author of *The Cat's Tail*, for her moral support and persistence; Robert Orr, author of *President Andrew Johnson of Greeneville, Tennessee*; and Louise Orr for their wonderful interest in preserving the history of this community and sharing their vast knowledge.

Every contributor, whose recognition is given after each image, holds a special place in my thoughts. It was delightful to have so many precious memories revealed for me to share with the readers of this book.

Special thanks to my son, Frank. Without his technical guidance, I would have been lost.

The materials presented in this book are merely a small portion of the amazing attributes of the citizens that have made this community what it is today. To properly represent the entire vicinity would take several volumes. I sincerely hope I can continue to pursue this presentation of human-interest photography.

INTRODUCTION

Greeneville has come a long way since the days of the Woodland Indians, the first known occupants of the area. In 1772, Jacob Brown secured a lease, which led to the purchase, of a vast amount of acreage from the Cherokee Indians. This area had an abundance of rich soil and wild game and encompassed land on both sides of the Nolichuckey River, including much of current Washington and Greene Counties. It was not until 1778 that a great influx of settlers came to the region, and among these was Anthony Moore. He settled in the Tusculum area, and his daughter is believed to be the first white child born in this vicinity. Daniel Kennedy, a Maryland native, found his way to the area. He was honored with a seat on the Washington County Court as a result of his gallantry in the Battle of King's Mountain. His interest in the region grew and resulted in a division of the lower part of Washington County from the upper portion. He was successful with his mission when, in 1783, the County of Greene came into existence as it passed the North Carolina House of Commons. In 1784, the court levied taxes on property to construct public buildings in the downtown area. Robert Kerr and others had found an interest in the land in the present site of Greeneville, near the Big Spring, and received a grant for 300 acres, 50 acres of this property being the present metropolitan site. This was divided into lots and sold accordingly. The first merchant was Andrew Greer, a prominent trader with the American Indians. By 1800, other important citizens established themselves in Greeneville, including James Stinson, county register and tavern keeper; Robert Kyle, tailor; William Dickson, Joseph Brown, and John Russell, merchants; and Valentine Sevier, nephew of Gov. John Sevier.

Greeneville began to evolve into a growing community and business district. Andrew Johnson arrived in the town in 1826 and by 1827, at the age of 19, had married Eliza McCardle. From his purchase of a tailor shop to his activity in politics, he had a keen sense of fairness and a desire to serve the public. The Civil War of course had an impact on Greeneville, as it did to all towns. This may be the only county seat in the United States to have monuments both to the Union and the Confederate causes of the war, reaffirming that the Civil War was, in fact, a brothers war. With the end of the Civil War came new industry as a town and a nation were trying to recover. Businesses such as the Lamons Wagon Company and the Greeneville Woolen Mills were established. The first train arrived in 1858. The Greene County Fair began in 1870. Along with a tremendous agricultural presence, the burley tobacco industry took off in the early 1900s under the capable guidance of John S. Bernard and Clysbe Austin. Tobacco became the livelihood of many Greene County farmers.

The religious community played an integral role in the establishment of Greeneville as a thriving town. In the mid- to late 19th century, many churches of varying denominations were being constructed. Education has always been an important part of our heritage, as was evidenced as early as 1780 when Dr. Samuel Doak established Martin Academy, which eventually became Washington College Academy. Chartered in 1794, Greeneville College officially opened, thanks to almost 20 years of efforts by Hezekiah Balch. By 1818, Dr. Doak had resigned his presidency at Washington College and joined his son, Samuel Witherspoon Doak, who had established

the private school Tusculum Academy. The Tennessee legislature changed the name of the academy to Tusculum College in 1844. Greeneville College and Tusculum College were merged in 1868 to form the Greeneville and Tusculum College, which, years later, retained the name of Tusculum College.

While this introduction gives only a brief synopsis of the early establishment of the community, the images in this book reveal a glimpse of the human interest history of Greeneville beginning around 1900. With the vast history of the area and the surrounding beauty of the Smoky Mountains and fertile farmland, it is no wonder that Greeneville enjoys a thriving tourist industry. It seems visitors come from afar to experience our quaint and charming town. Many have been known to return to live here.

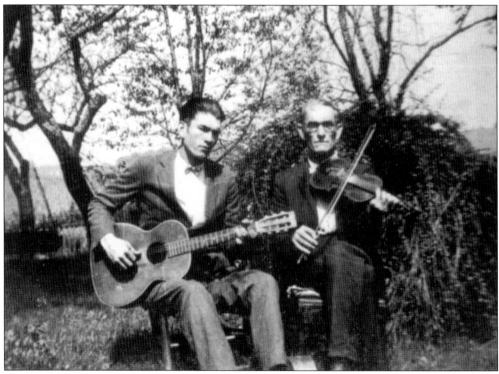

In the 1920s, Walter Taylor, left, and his father, Andy Paul Taylor, played the guitar and violin strictly for their own enjoyment. (From the collection of Mr. and Mrs. Arthur Southerland.)

One

FAMILIES AND FRIENDS

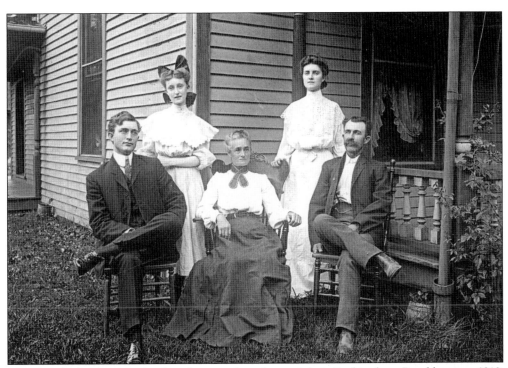

The Temple family poses for this photograph in front of their Buckingham Road home c. 1910. John E. McGaughey built the house in the 1850s. Pictured from left to right are Charles Temple, Margaret Temple, Julia Rankin Temple, Hassie Temple (Armitage), and Bud Temple. (Courtesy of Louise Orr.)

This 1920 family photograph shows the Whites in front of their home. From left to right are (first row) Joe White and Minnie White; (second row) Charlie, Mabel (Stair), and Everette; (third row) Fannie (Wells) and Edith (Alexander). The house is believed to have been built in the 1840s and has remained in the family. (Courtesy Mr. and Mrs. Bill Alexander.)

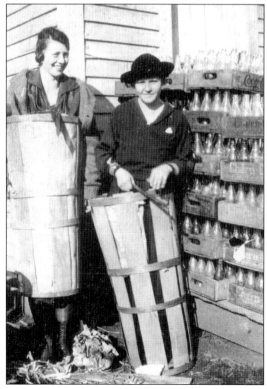

In 1927, Myrtle Baskette Dobson (right) is having fun with a friend outside Dobson's Grocery. The banana crates made for interesting props. (Courtesy of Mrs. Harold Dobson.)

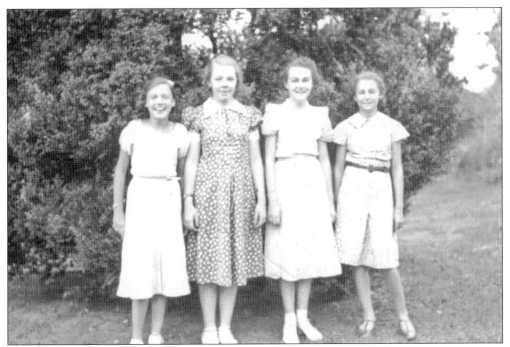

In 1937, these four girls were the best of friends. They are, from left to right, Frances Carter, Margaret Galbreath, Nancy Cowles, and Jane Brown. (Courtesy of Mrs. Harold Dobson.)

The Honorable Eugene A. Wilson served as assistant postmaster from December 13, 1915, until November 30, 1948. He was appointed money order clerk on April 1, 1902. (Courtesy of the Nathanael Greene Museum.)

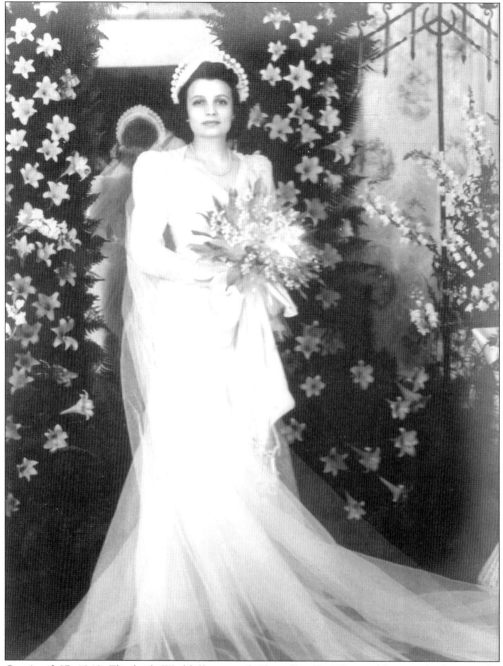

On April 27, 1940, Elizabeth Waddell married Chris Saville. The wedding took place at the Waddell home on Church Street. (Courtesy of Mrs. Chris Saville.)

Frances and Paul Baskett sat for this photograph shortly after their wedding in 1937. (Courtesy of Frances Million.)

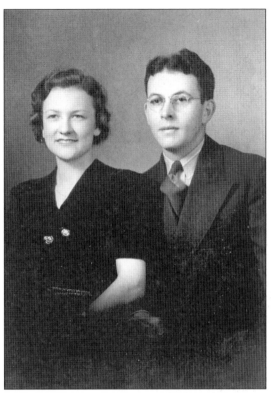

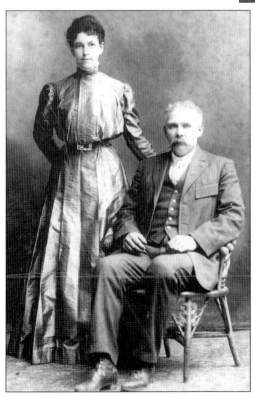

Izetta and Richard Baskett posed for this portrait c. 1910. (Courtesy of Frances Million.)

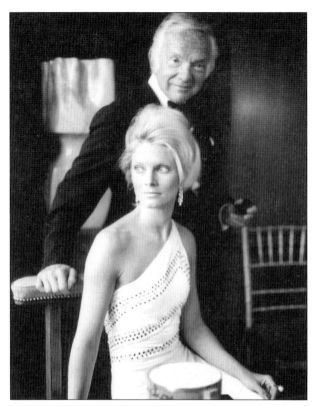

In the early 1970s, Suzanne Waddell married Hollywood producer Mark Goodson. They met when Suzanne was a guest on the television show *What's My Line?*. (Courtesy of Mrs. Chris Saville.)

W. C. Waddell Sr. is pictured in 1910 with his sons, William Cate Waddell Jr. (left) and John Alfred Waddell. W. C. Jr. died when he was seven years old from ptomaine poisoning after eating a blackberry pie. (Courtesy of Mrs. Chris Saville.)

From left to right, Josephine Brabson, Helen Krebbs, Harriet Neff, and Matilda Bowen were posing in front of Hillwinds on the occasion of the wedding of Mrs. Bowen's daughter, Matilda. (Courtesy of Mrs. Elba Bowen.)

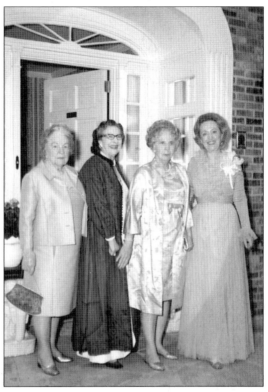

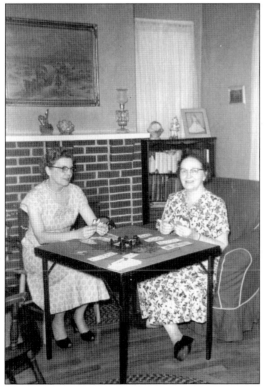

Elizabeth Wagner Rasar (right) enjoys a game of canasta with her sister-in-law, Bonnie Moreland Wagner, in this 1957 photograph. (Courtesy of the author.)

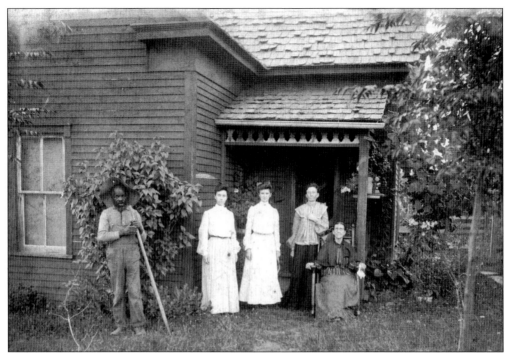

This Carson Street house was built in the late 1800s. Pictured in front of the house from left to right are Owen Allen Henry, two Carson daughters, Margaret Henry Mercer, and Mrs. Carson. At the time of this photograph, Margaret Mercer owned the home. "Uncle" Owen Henry had come to live with Margaret's parents, Samuel and Mary Henry, after becoming separated from his own parents at the close of the Civil War. (Courtesy of Wanda Royall Sauceman.)

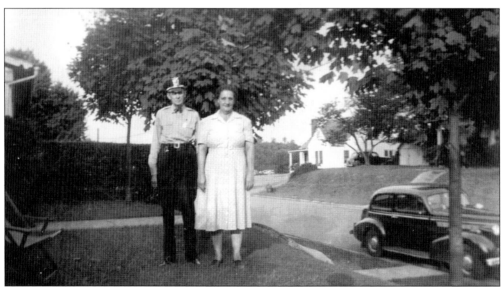

This 1940s photograph shows William Franklin Royall Sr. and his wife, Edith Koontz Royall, standing in the front yard of their home on Carson Street. William was a policeman in Greeneville for 35 years. For many of these years, he was the only policeman on duty at night. (Courtesy of Wanda Royall Sauceman.)

Wanda Royall stands behind her desk in 1942 at the local Draft Board. During the two years she worked there, her duties included preparing paperwork that went with the men being shipped out. At that time, Monte Carter Hunt was her boss, and D. Catron Lawson was the head of the draft board. The draft board was located in the post office building on Summer Street. (Courtesy of Wanda Royall Sauceman.)

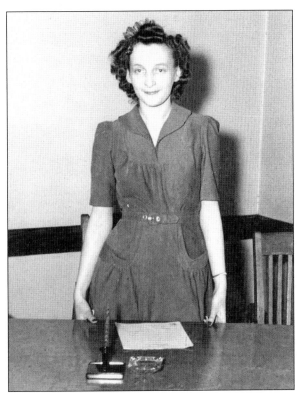

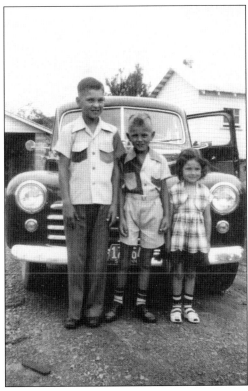

The family car was often the choice backdrop for family snapshots. In 1952, from left to right, Jerry, C. W., and Eva Baskett are captured in front of their parent's automobile. (Courtesy of Frances Million.)

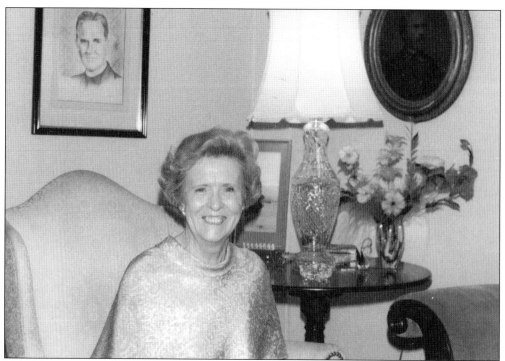

Lanthe Rush Campbell poses in front of her husband's portrait in this 1977 photograph. (Courtesy of Greeneville–Greene County Library, Lanthe Rush Campbell collection.)

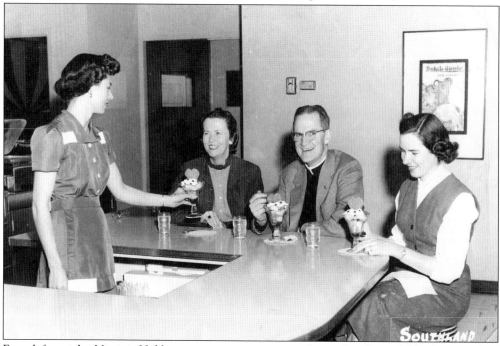

From left to right, Virginia Hubbs serves tasty ice cream sundaes to Lanthe and Charles Campbell and a friend in this late-1950s photograph. (Courtesy of Greeneville–Greene County Library, Lanthe Rush Campbell collection.)

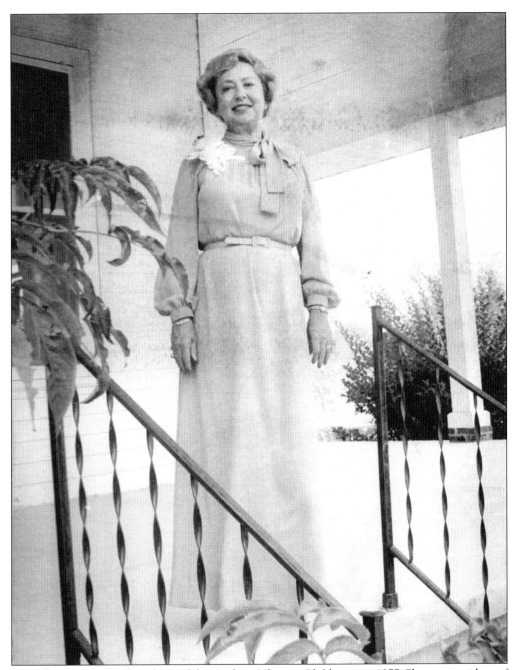

Mrs. Elba Bowen stands in front of the Andrew Johnson Clubhouse in 1977. She was president of the club from 1977 to 1979 and again from 1981 to 1983. In her many duties in the club, among her favorite has been delivering candy and fruit to the patients of the James H. Quillen Veterans Affairs Medical Center at Christmas. Mrs. Bowen has also served as president of Youth Builders of Greeneville, Inc., and has been affiliated with several community organizations. She was the proud recipient of the Personalities of the South award in 1979 by the Historical Preservations of America and the Outstanding Woman of Greene County award in 1980. (Courtesy of the Andrew Johnson Women's Club.)

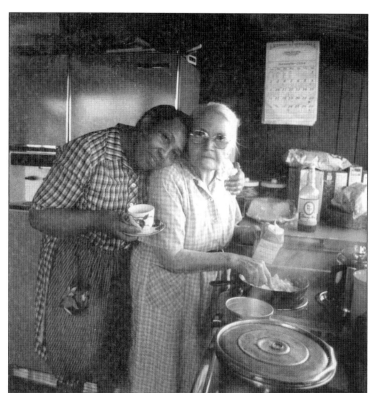

Mary Lee Miller and Annie Ida Isbel Hale prepared many delicious meals together at Hilltop. In this 1974 photograph, Dumplin is at the stove, while Mary Lee gives her an adoring hug. (Courtesy of the John M. Jones family.)

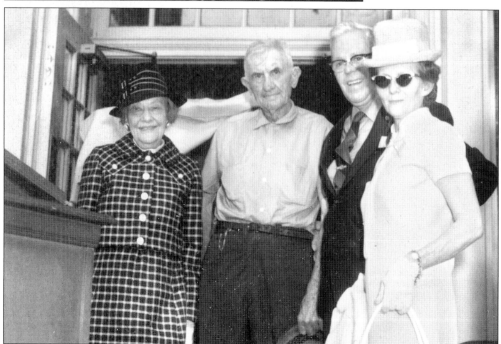

On the occasion of hanging a portrait of John Bernard in town hall, pictured from left to right c. 1970 are Edith Susong, Jim Mercer, Mayor James Hardin, and Ina Hardin. (Courtesy of the John M. Jones family.)

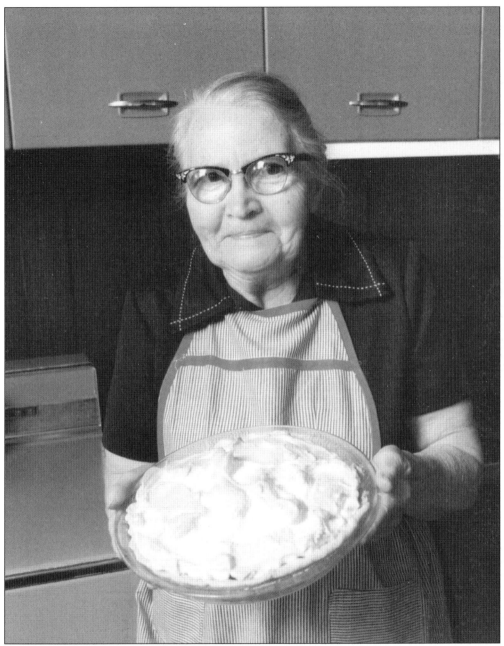

Annie Ida Isbel Hale is pictured here *c.* 1977. She is proudly holding one of her famous meringue pies. She was known to have dispensed with a pie if the meringue did not turn out just perfect! "Dumplin," as she was fondly known, was not only chief cook and nanny to the Jones family but became a complete member of the family and a great friend to many. (Courtesy of the John M. Jones family.)

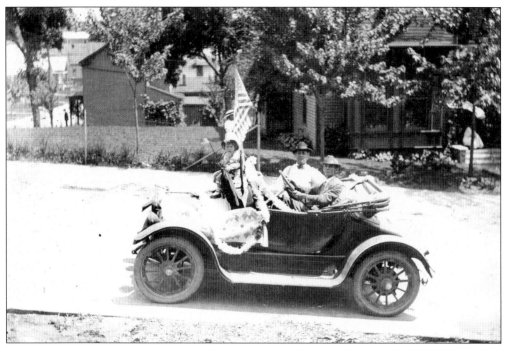

In 1917, Ebb Sentelle (behind the wheel), John T. McDonald, and John Bill McDonald (sitting on the dashboard) are posing in this vintage car in front of the W. C. Waddell home on Church Street. (Courtesy of Mrs. Chris Saville.)

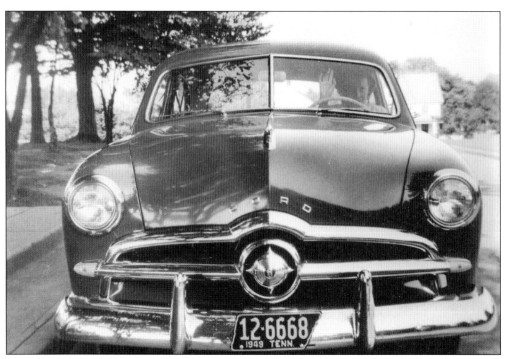

Mary Nelle Royall (Jackson) sits behind the wheel of this shiny Ford. This 1949 photograph indicates the pride taken in vehicles of this era. (Courtesy of Wanda Royall Sauceman.)

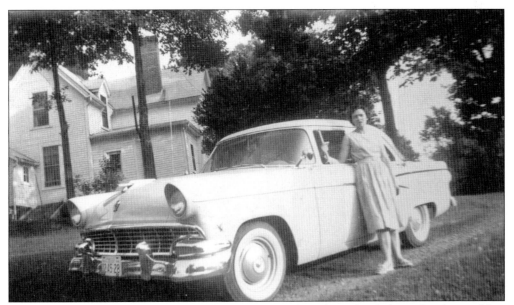

Helen Smith Southerland stands beside the 1956 Ford Fairlane that belonged to her and her husband, Arthur. This snapshot was taken on the grounds of Tusculum College. (From the collection of Mr. and Mrs. Arthur Southerland.)

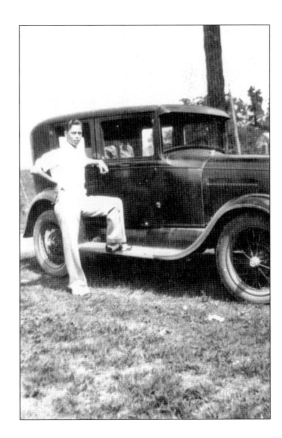

This is the first picture that Gertrude Hawk ever had of Claude "Coon" Dodd. He was standing next to his vintage automobile in the mid-1920s. Coon and Gertrude were married in 1929. (Courtesy of Gertrude Dodd.)

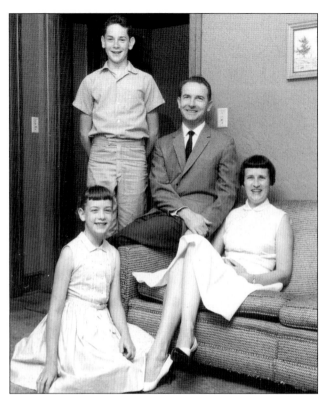

The Simons pose for this 1960s family photograph. Pictured are Dr. Hugh Simon, Mrs. Sophie Simon, and their children, Celia and Hugh Jr. (Courtesy of Mrs. Hugh Simon.)

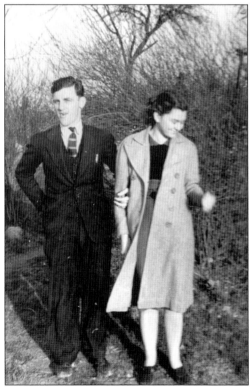

In 1939, Arthur and Helen Southerland were newlyweds. They are seen here walking on Arthur's Uncle Bob Boswell's farm in the Fairview community. (From the collection of Mr. and Mrs. Arthur Southerland.)

Robert Orr is captured here in 1970 while playing his guitar. His musical talents have wooed the community for several years. (Courtesy of Louise Orr.)

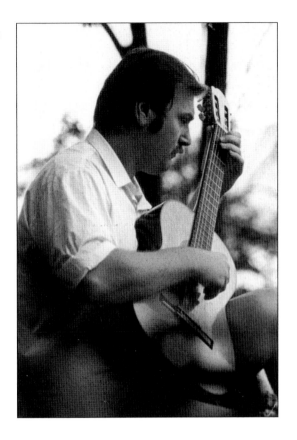

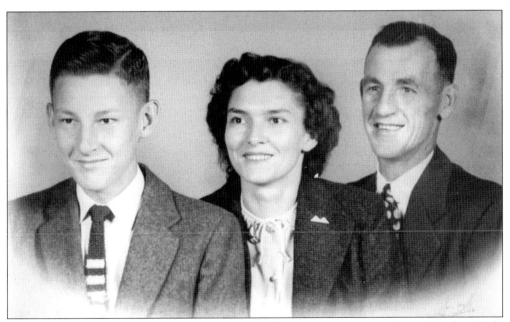

In 1955, Jimmy Southerland and his parents, Helen and Arthur Southerland, posed for this family portrait. (From the collection of Mr. and Mrs. Arthur Southerland.)

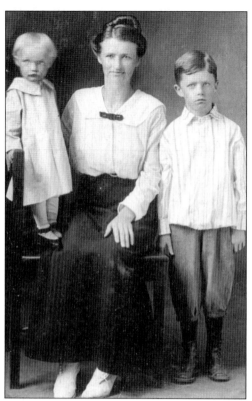

Chassie Branch Colyer poses with her children, three-year-old Glenna Mae and seven-year-old Walter Frederick "Jim," in 1919. (Courtesy of Eleanor Eacret Mosca.)

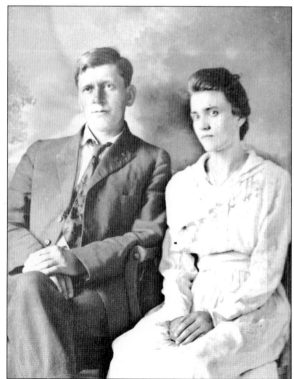

John Robert Smith and Bertha Mae Taylor Smith were married on May 12, 1918. They eventually had two girls and six boys. (From the collection of Mr. and Mrs. Arthur Southerland.)

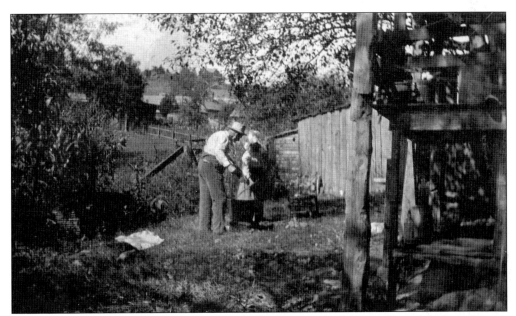

James Harvey Robinson is seen in the backyard of his house on Irish Street. He and the housekeeper, "Aunt" Minerva Clem, are busy making apple butter in this 1905 photograph. (Courtesy of Louise Orr.)

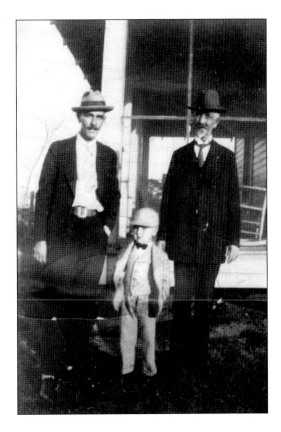

Frank P. Robinson III is flanked by Frank P. Robinson Jr. (left) and Dr. Frank P. Robinson Sr. in this c. 1925 photograph (Courtesy of Louise Orr.)

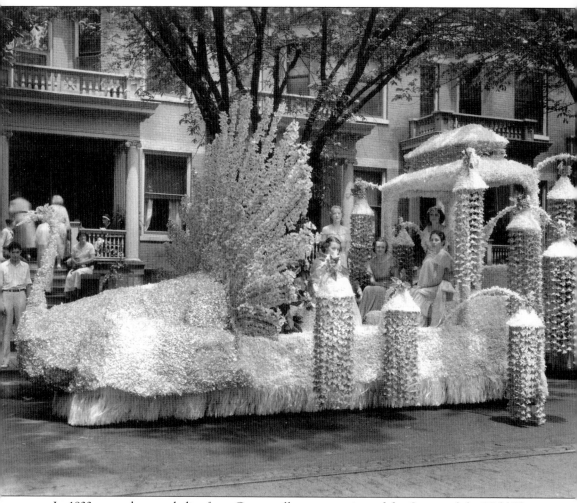

In 1933, several young ladies from Greeneville were nominated for Queen of the Wild Flower Festival in nearby Knoxville. Representing Greeneville on this beautiful float are, from left to right, Arnold Susong (Jones), Louise Bullen (Lunsford), Lois Armitage, (seated) Elizabeth Russell (Waddell), and Elizabeth Waddell (Seville), standing and wearing the crown of the queen. The boy standing on the sidewalk at the far left is Clyde B. Austin Jr. (Courtesy of Louise Orr.)

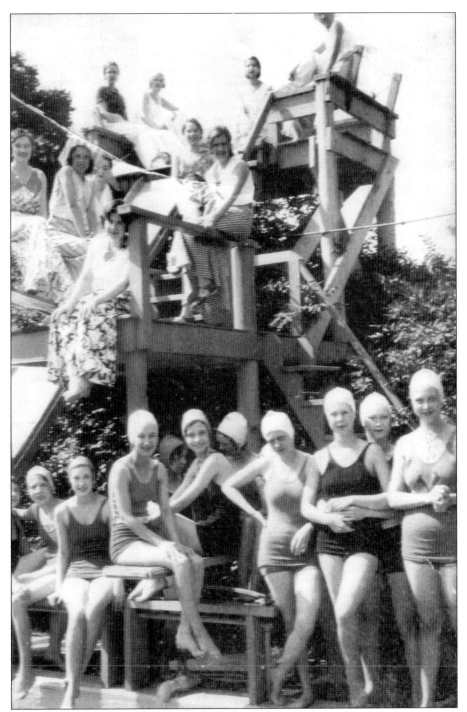

In 1927, these bathing beauties posed by the swimming pool at Judge Dana Harmon's residence. Included here are Alice Larue, Florence Lancaster, Dorothy Brown, Eleanor Missmer, Dorothy Carter, Anna Ruth Biddle, Margarite O'Keefe, Mildred Rankin, Martha Irwin, Elizabeth Brown, Elizabeth Wilson, Mary Ruth Hawkins, Mary Moore, Charlotte Lancaster, Dorothy Mason, and Marjory Trim. (Courtesy of Mrs. Chris Saville.)

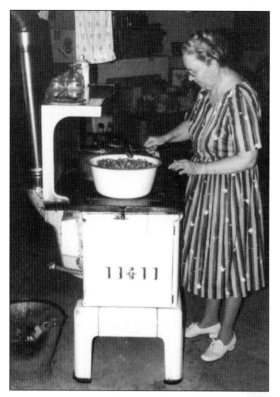

Glenna Mae Colyer Eacret is found at her Athena stove, which was purchased in 1942. The stove used coal and wood and had a separate water tank. The warmer tray was on top, and the thermostat was on the middle of the oven door. Glenna is seen in this 1974 picture making "piccalilli" with green tomatoes and other fresh garden vegetables from her own garden. (Courtesy of Eleanor Eacret Mosca.)

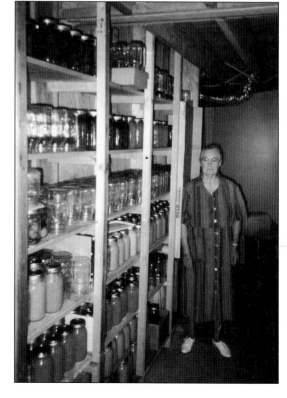

Glenna Eacret looks proud of all her canned goods. It took quite a long time to put up all the delectable goodies from the garden, which was enjoyed all year long. This was a common sight since store-bought goods were an extravagance in this area. (Courtesy of Eleanor Eacret Mosca.)

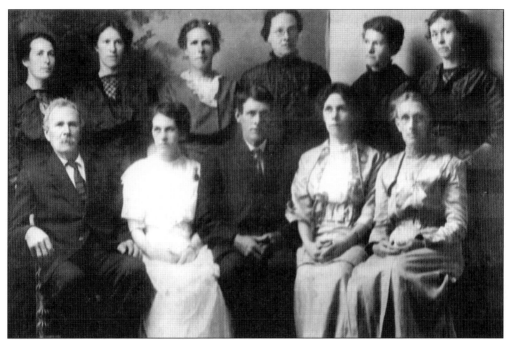

Arthur Robert Million and Mahale Jane Blakely were married on November 11, 1866. This *c.* 1900 Million family portrait includes the Millions and their nine children. From left to right are (first row) Arthur Robert (1848–1932), Laura E. (1887–1958), James Matthew, (the only boy, 1876–1955), Georgia Virgil (1885–1960), and Mahale Jane (1847–1923); (second row) Clara Ina (1883–1922), Daisy Viola (1881–1958), Lillie Belle (1870–1942), Anna Elizabeth (1867–1956), Charity Izetta (1878–1962), and Mary Elizabeth (1874–1954). (Courtesy of Frances Million.)

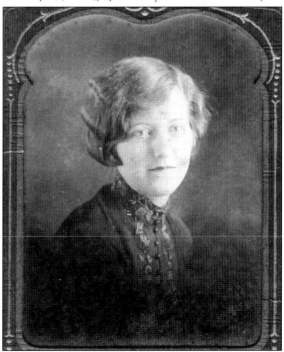

Gertrude Hawk (Dodd) is captured in this *c.* 1926 photograph. (Courtesy of Gertrude Dodd.)

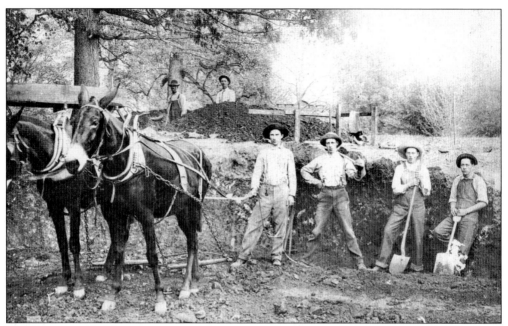

Will Simpson is holding the reigns of the team in this c. 1922 photograph. These men stopped their work building Rankin Hall at Tusculum College just long enough to have their picture taken. Will's daughter, Margaret (Gaut), recalls riding on the wagon that brought sand from the Nolichuckey River to the work site and helping unload. On the far right is Mont Todd. (Courtesy of Mr. and Mrs. William King Gaut.)

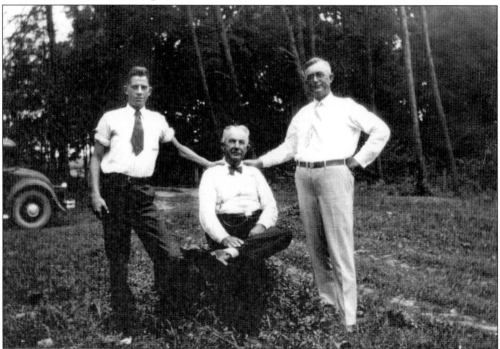

Three generations of Temples are posing for this 1940s picture. From left to right are Charlie Temple (son), M. J. "Bud" Temple (father), and Charles Temple (grandson). (Courtesy of Louise Orr.)

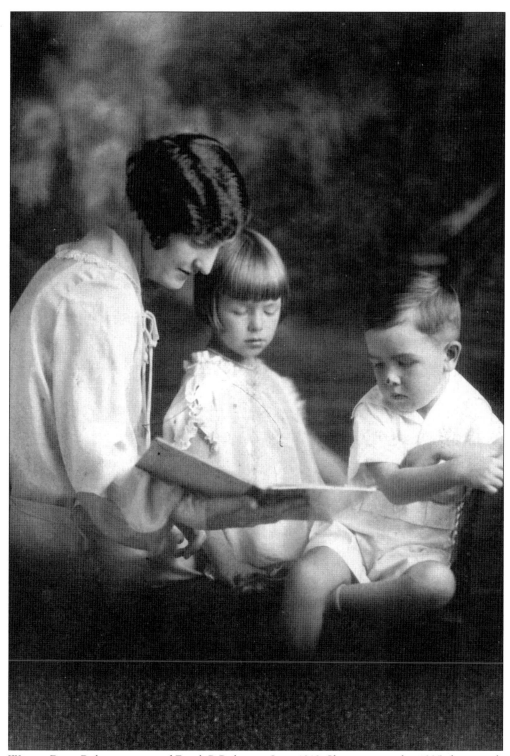

Winnie Davis Robinson married Frank P. Robinson Jr. in 1918. She is seen in this 1925 photograph reading to her children, Louise and Frank III. (Courtesy of Louise Orr.)

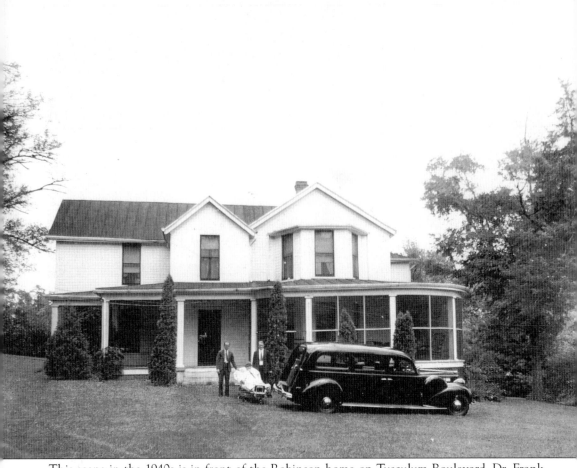

This scene in the 1940s is in front of the Robinson home on Tusculum Boulevard. Dr. Frank Robinson Sr. is being taken on a stretcher to the waiting ambulance in order to vote. Dr. Robinson had broken his hip and would not miss an election. His friends Bill Wright, on left, and Clark Kiser helped with these arrangements. Kiser, a Democrat, enjoyed canceling Dr. Robinson's Republican vote. (Courtesy of Louise Orr.)

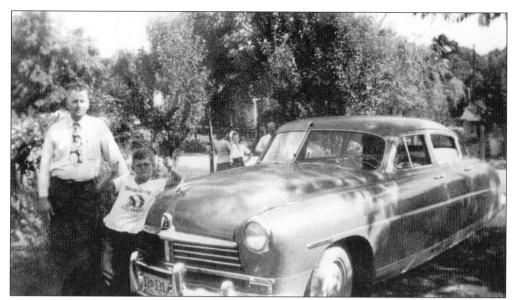

Theo Leland Eacret stands with his nephew, William Eacret, in front of his 1949 Hudson. This light blue, four-door model was called a "Commodore Custom Sedan" and had room for six passengers. It touted a 124-inch wheelbase and a 128-horsepower improved super-eight engine. There were 10 colors to choose from. Note the larger windows for improved visibility. (Courtesy of Eleanor Eacret Mosca.)

In this 1942 photograph, Nancy Kate Peters stands next to her family's vintage automobile. (Courtesy of Wanda Royall Sauceman.)

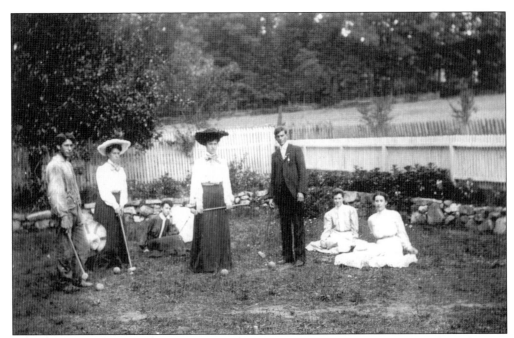

At the Million home in Clear Springs, a popular way of entertaining "beaux" was a leisurely game of croquet on the front lawn. In the center of this 1901 photograph is 18-year-old Izetta Million (Baskett) with three of her six sisters along with apparent suitors. (Courtesy of Frances Million.)

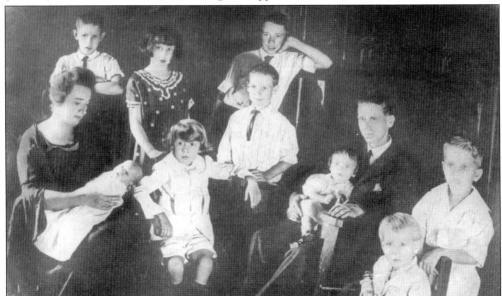

This c. 1924 family portrait is of the Allen C. Duggins family. From left to right are (first row) Clarice (holding Joseph Allison), Charles, L. W., Allen C. (holding John), Ray, and Victor; (second row) Cameron, Adelia, and Allan. The Duggins had three more children after this photograph was taken. Allen C. Duggins came to Greeneville around 1918 and became the superintendent of the city schools. He taught at Greeneville High School and a few county schools. Eight of the Duggins boys served in World War II and all returned home, having escaped injury. (Courtesy of Hertha Duggins.)

Standing in front of their smokehouse in 1936 are Charlie Colyer and his wife, Chassie Branch Colyer. This building was originally used for smoking hams and was later converted to a washroom. (Courtesy of Eleanor Eacret Mosca.)

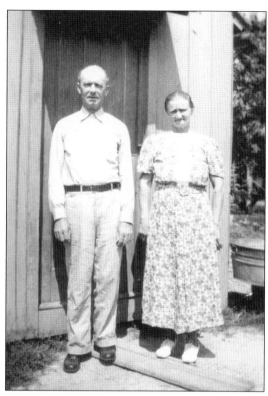

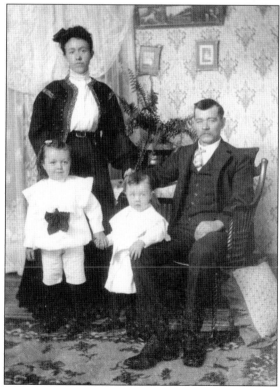

Mary Elizabeth was one of the nine children of Arthur and Mahale Million. She and her husband, M. E. Gourley, pose for this 1905 family portrait with their sons, Arthur (left) and Otis. (Courtesy of Frances Million.)

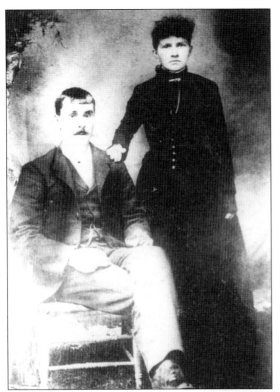

This mid-1880s portrait is of William Henry Smith and his wife, Mollie Harrison Smith. William died as a result of a gunshot wound when his gun fell from his pocket while unloading cuspidors at the county courthouse. He was sheriff of Greene County at the time. He and Mollie were the parents eight children. (From the collection of Mr. and Mrs. Arthur Southerland.)

Sophie Vass (Simon) is pictured here in 1921. Sophie has been active in several organizations in Greeneville, including Youth Builders, Greene Valley Gray Ladies, Community Concerts, and the Daughters of the American Revolution (DAR). (Courtesy of Ms. Hugh Simon.)

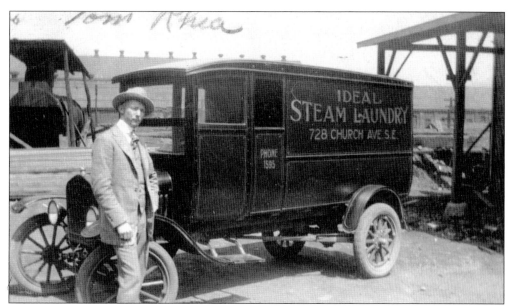

Tom Rhea is shown next to the company truck of Ideal Steam Laundry c. 1920. Notice the telephone number is only four digits. The cleaning service was located in the heart of downtown Greeneville. (Courtesy of Gertrude Dodd.)

The Brooks family gathered for this picture in the 1930s. Found in the front row from left to right are Elizabeth Brooks Ricker, Belva Brooks Ricker, and Luster Brooks Broyles. The gentlemen standing from left to right are Claude Brooks, Clarence Brooks, Tom Brooks, and Bob Brooks. The photograph was taken at the Brooks home on Bird's Bridge Road. (Courtesy of Leo and Jean Birdwell.)

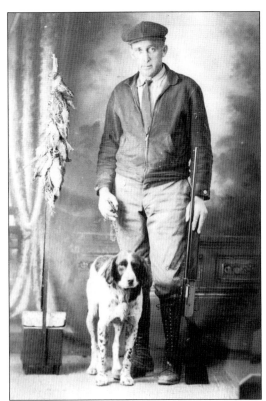

Bob Lane is posed in this c. 1940s photograph with his spaniel, his over-under 410-22, and several doves. He was proud of "15 singles out of 21 shots in three hours." (Courtesy of Howard O. "Buddy" Lane.)

Blanche White (Grady) is pictured here in 1924 holding her dog, Ted, and Dolly Lou. (Courtesy of Mrs. Blanche W. Grady.)

Brothers George and Bob Lane posed for this 1935 picture. They had commented to each other about their difference in haberdashery styles. (Courtesy of Howard O. "Buddy" Lane.)

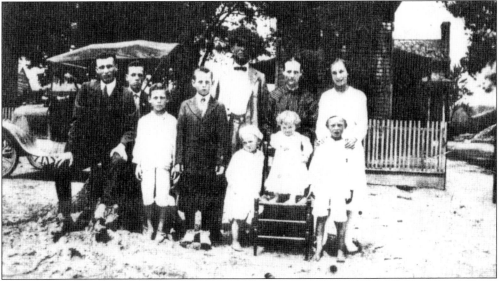

This c. 1918 photograph shows the family of Zacharia and Alfreida White. From left to right are Owen, Harlan, Cyril, Alvin, Zacharia, Luther, Blanche (standing on chair), Alfreida (behind Blanche), Merrit (front), and Ruth (behind Merrit). The ninth child, Hosea, is taking the picture. When going to church, the entire family could not fit into the Model T. Some rode on horseback, and some rode their bicycles. Blanche and her mother always got to ride in the Model T. The boys took turns getting the car for dates but had to sign up in advance. (Courtesy of Mrs. Blanche W. Grady.)

This 1910 wedding picture is of Georgia Alma McKay (Lane) and George Ruther Lane. They had two children, Wanna Lea and Howard Orton. (Courtesy of Howard O. "Buddy" Lane.)

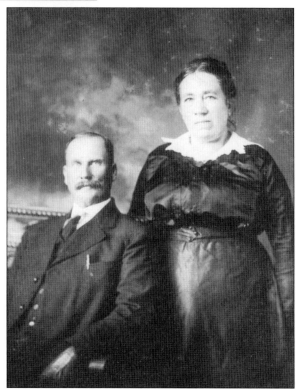

C. F. and Lilly Rambo Brooks pose for this portrait in the late 1800s. They were from the Camp Creek area. (Courtesy of Leo and Jean Birdwell.)

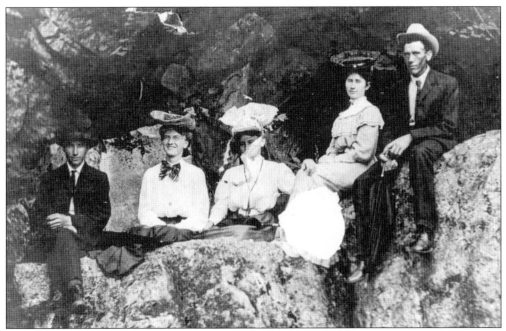

From left to right, Will Simpson, Mollie Simpson, Flora Simpson, and two friends enjoy an apparently typical mountain outing in this *c.* 1910 photograph. Note the wonderful period hats worn by all. (Courtesy Mr. and Mrs. William King Gaut.)

Mollie and Flora Simpson wear their homemade outfits while relaxing on a spring day around 1905. (Courtesy of Mr. and Mrs. William King Gault.)

Theo Leland "Big Boy" Eacret was a barber for Clark Parman at the beginning of his career and at the time of his retirement at age 80. It was by accident that he began his tenure with Clark. Theo, who had come to Greeneville from Los Angeles, was walking down Depot Street near Parman's barber shop when a barber from the shop stepped outside and asked if Theo would mind watching the shop while he went to lunch since the owner, Clark Parman, was on vacation. Theo agreed, expecting the employee to return promptly, but that employee never did return. When Clark returned a week later, he was surprised to find Theo running his shop, and Clark hired Theo. Although Theo worked at several barbershops, he returned to Clark's new shop, the Palace Barber Shop, for the last years of his career. This 1951 photograph shows Theo at Stroud's Barber Shop on Main Street. (Courtesy of Eleanor Eacret Mosca.)

John Robinson had recently arrived in New York City in this 1940s photo. John's musical and acting talents took him to New York, where he performed on stage and played with several renowned jazz bands, showcasing his abilities as a drummer and pianist. (Courtesy of Louise Orr.)

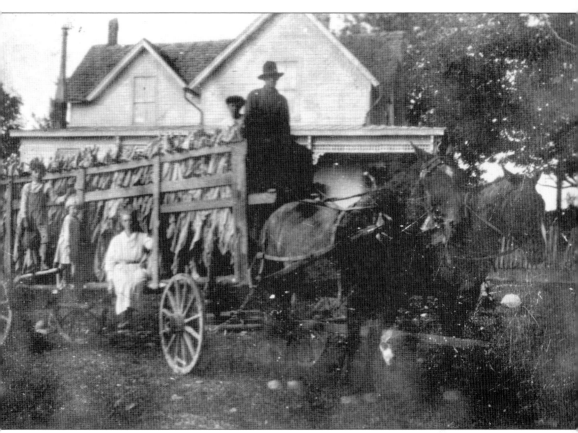

In this mid-1930s photograph, fresh-cut tobacco is being taken from the fields to the barn on the Basketts' 230-acre farm. Frances Million remembers baking at least three pumpkin pies a day along with having an abundance of potatoes and beans to feed the farm workers. Richard Baskett built the beautiful house. (Courtesy of Frances Million.)

Theo Leland Eacret and his wife, Glenna Mae Colyer Eacret, pose for this portrait shortly after their wedding in December 1937. They had met in person only twice but had been exchanging letters for six years since Theo was serving in the Marine Corps. (Courtesy of Eleanor Eacret Mosca.)

This 1920s photograph is of Ruth Gladys Davis. Ruth married Jay C. Bullen in 1920, and together they had one son, J. C. Bullen Jr. After Jay's death, Ruth married John S. Bernard Jr., mayor of Greeneville. Because of health concerns, Ruth moved to Tucson, Arizona, where she died in 1982. (Courtesy of Gertrude Dodd.)

Two

YOUTH

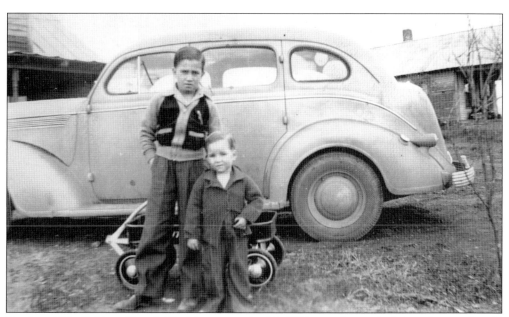

Brothers Billy (left) and Lyndel Smith are seen in this 1938 snapshot with their red wagon beside the family's 1937 Desoto. (From the collection of Mr. and Mrs. Arthur Southerland.)

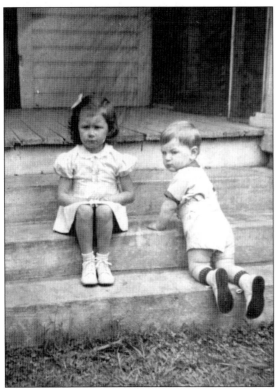

Ellouise Orr (Trepanier) seems to be more patient for the photographer than her brother, Robert Orr. They are seen on the steps of their home around 1955. (Courtesy of Louise Orr.)

Paul Baskett, son of Izetta and Richard Baskett, is pictured here c. 1921. (Courtesy of Frances Million.)

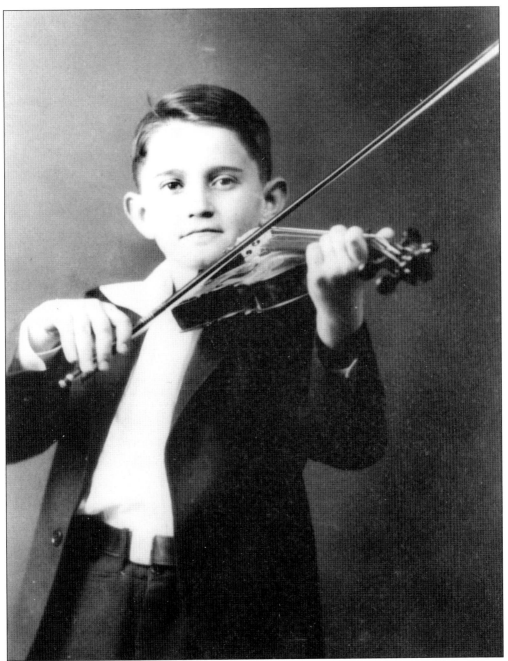

Howard Orton "Buddy" Lane was about 10 years old in this 1934 picture. He enjoyed getting out of school early and being allowed to leave via the fire escape at Roby School to take violin lessons from Mr. Kratochewell. Although Buddy had chosen the gift of a violin over a pony, he found the violin was not as enjoyable an instrument as he had hoped. Even though he had played the violin for several years, he switched to the clarinet for the next few years. (Courtesy of Howard O. "Buddy" Lane.)

As was customary in the early 1920s, Harold Dobson donned a bonnet crocheted by his mother for this portrait. (Courtesy of Mrs. Harold Dobson.)

This *c.* 1950 photo shows, from left to right, John Jones Jr., Gregg Jones, and Alex Jones enjoying a favorite comic book. All the Jones boys have made a career in journalism. Alex was awarded the Pulitzer Prize in specialized reporting in 1987 for his articles on the collapse of the Bingham family's newspaper empire in Louisville, Kentucky. Together with his wife, Susan Tifft, Alex coauthored *The Patriarch: The Rise and Fall of the Bingham Dynasty* as well as *The Trust*. (Courtesy of the John M. Jones family.)

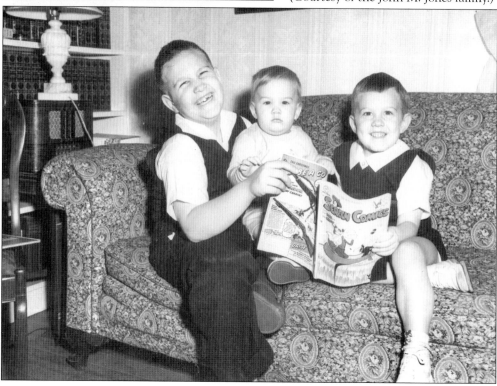

Woodrow Hawk is seen at the end of the driveway to the family home on Tusculum Boulevard in 1914. (Courtesy of Gertrude Dodd.)

Glenna Mae Colyer (Eacret) sits holding her new straw purse at age two. This photograph was taken in 1918. (Courtesy Eleanor Eacret Mosca.)

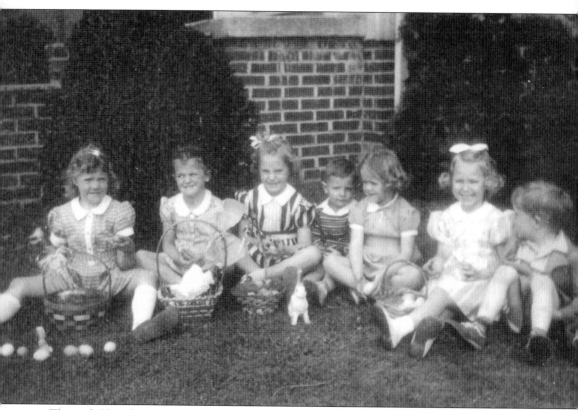

These children have been having fun hunting Easter eggs in this 1944 photograph taken at the L. K. Ricker home on the Newport Road. Pictured from left to right are Muriel Disney, Frances Ricker, Barbara Brown, Fred Ricker, Ann Ricker, Jean Hawk, and Jerry Disney. (Courtesy of Leo and Jean Birdwell.)

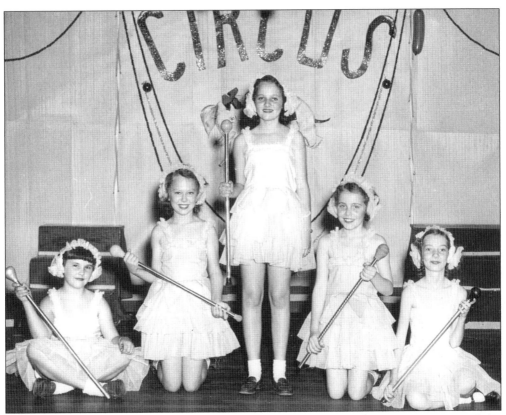

As part of a school production, the circus was in town at Crescent School. This 1949 picture includes the following lovely young performers from left to right: Carol Ann Larkin, Jean Hawk, Binnie Lee Renner, Frieda Reaves, and Betty Ellen Micken. (Courtesy of Leo and Jean Birdwell.)

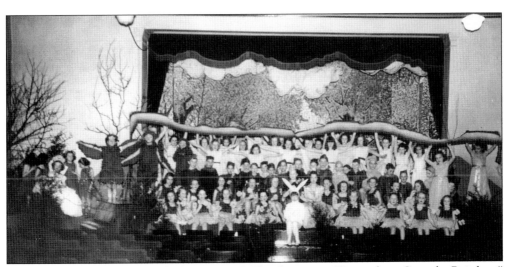

This Crescent School play took place in 1946. The theme was "Somewhere Over the Rainbow" and involved children from several grades. (Courtesy of Leo and Jean Birdwell.)

Hugh Simon is pictured in 1923 at age four. He was a native of Kansas and received his education at Washburn and Louisville Presbyterian Seminary. He was the pastor of Greeneville's First Presbyterian Church from 1960 until 1985. (Courtesy of Mrs. Hugh Simon.)

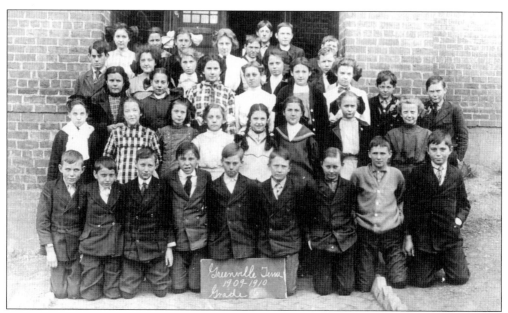

The sixth grade at the Roby Primary School poses for this 1909–1910 class picture. Edith O'Keefe (Susong) is far right in the second row. (Courtesy of the John M. Jones family, Edith Susong Collection.)

54

In the early 1960s, the DAR sponsored a fund-raising fashion show. The event was held at the home of Richard Doughty. These young ladies and gentleman await their turn to present the spring fashions they wear. Pictured here counterclockwise from top right are Sally Jones (Harbison), Edith Jones (Floyd), Diana Davenport, Spencer Smith, and Jeannie Tallent (Jackson). (Courtesy of the John M. Jones family.)

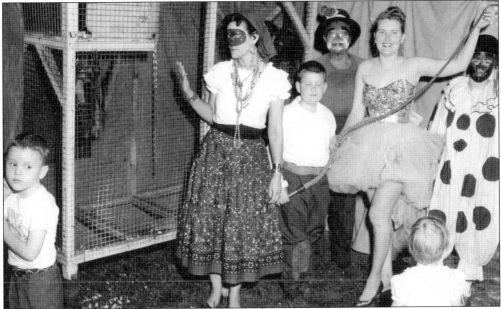

On Alex Broyles's sixth birthday, he was pleasantly surprised with a circus production, compliments of his imaginative mother, Jean. This 1955 party, held at Windrock, included live and pretend animals, clowns, and cotton candy. Note the real monkey in the cage at left. Shown in this photograph from left to right are Lynn David, Isabel Sites, Alex, Bessie Elder, Jean Broyles (holding a "snake"), and Sylvia Kiser. Mr. Broyles was really surprised to come home that day and find a real tiger cub in his recreation room! (Courtesy of Mrs. Alex C. Broyles Jr.)

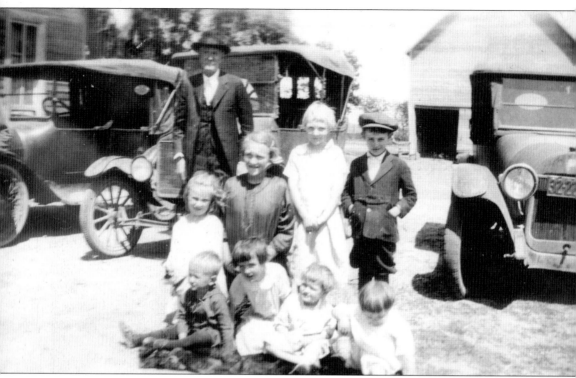

Richard Baskett stands behind a group of neighborhood and family children. His son, Paul, is standing at far right. Vintage cars are seen in the background. Richard was known to have the first car in the Clear Springs area. This photograph was taken around 1919. (Courtesy of Frances Million.)

In 1926, Walter "Jim" Colyer was promoted to the seventh grade. The principal was Roby Fitzgerald, and his teacher was Ethel Gosnold. (Courtesy of Eleanor Eacret Mosca.)

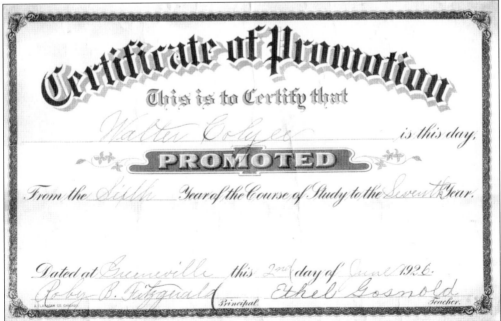

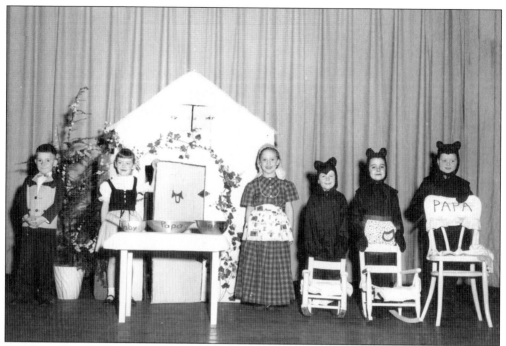

The Three Bears is always a big hit with children. This 1955 production by Roby School students in the Little Theater features Alex Broyles as Papa Bear (far right). Pam Benko (second from right) and Julie Harris (second from left) are two of the young actresses. (Courtesy of Mrs. Alex C. Broyles Jr.)

This was Vacation Bible School at the Church of the Nazarene *c.* 1945. Included in this photograph are Jack Lister, Lucille Branch, Patricia Thompson and her two sisters, Glenna Eacret, Eleanor Eacret, and Billy Ricker. (Courtesy of Eleanor Eacret Mosca.)

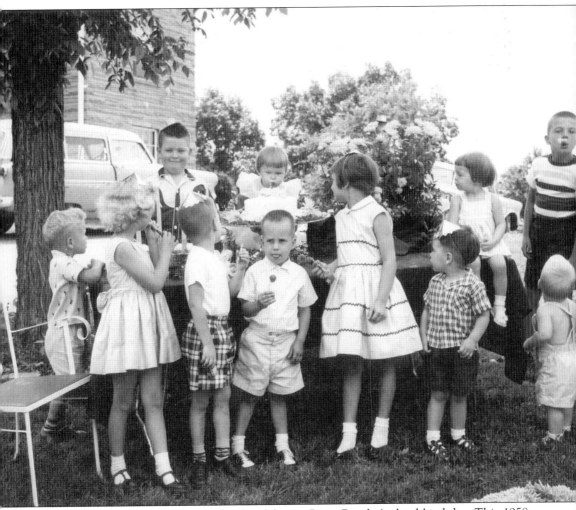

Another memorable party at Windrock celebrates Barri Broyles's third birthday. This 1958 photograph includes, in addition to the birthday girl (center, behind the cake), from left to right, David Howard, Sherra Howard, Alex Broyles (Barri's brother), unidentified, Bill Bewley, Debra Bewley, Nathan Horner, Luanne Kilday, and two unidentified. (Courtesy of Mrs. Alex C. Broyles Jr.)

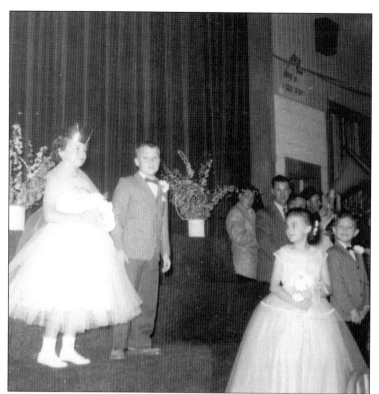

Phyllis Smith (Randolph), far left, stands next to Fred Dobson shortly after being crowned king and queen of Doak School c. 1960. (From the collection of Mr. and Mrs. Arthur Southerland.)

Eleanor Eacret (Mosca) is pictured here at age nine. She attended Crescent School when this picture was taken in 1947. (Courtesy of Eleanor Eacret Mosca.)

In 1961, Fred Sauceman and Gail Saulsbury were elected king and queen of the first grade at Eastview Elementary School. (Courtesy of Wanda Royall Sauceman.)

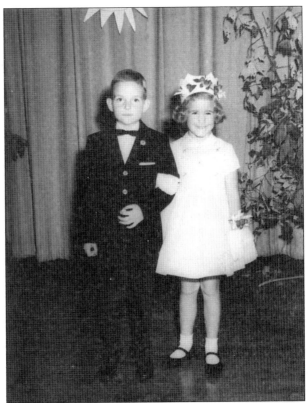

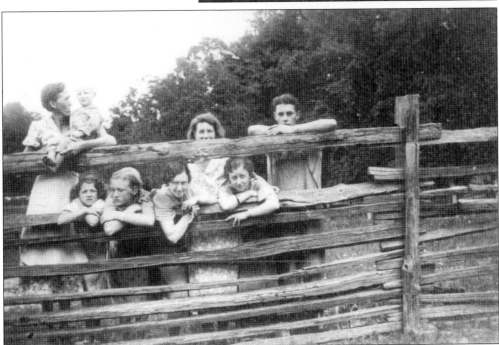

Rhoda Baskett holds her baby, Don, as other family children peer through the fence on their farm in Clear Springs, around 1928. (Courtesy of Frances Million.)

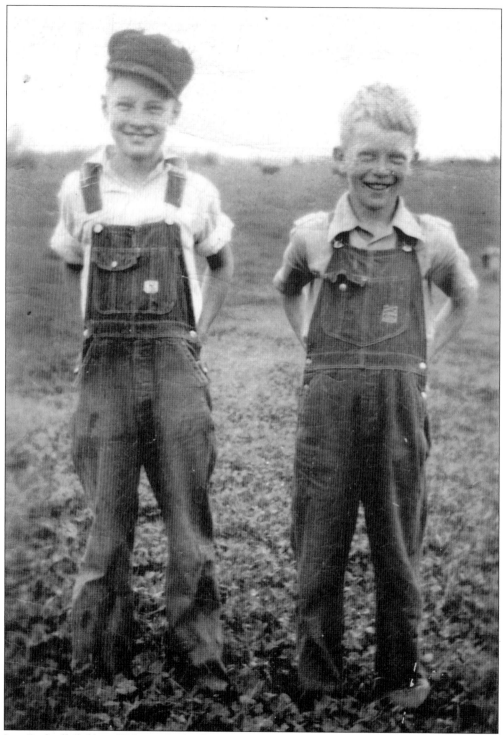

Leo Birdwell (left) and Johnny Birdwell pose for this 1944 picture in their overalls. They are on the family's 1,700-acre farm on Allen's Bridge Road, perhaps ready to do some chores! (Courtesy of Leo and Jean Birdwell.)

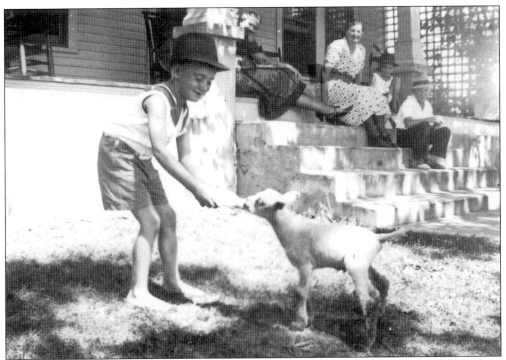

In 1935, six-year-old Bob Alexander seemed to be enjoying feeding a lamb. His brother, Walter, far right, and twin brother, Bill, are on the porch with their Aunt Fan Alexander and Mrs. Phillips (far left). The Phillipses raised sheep and were close family friends. (Courtesy of Mr. and Mrs. Bill Alexander.)

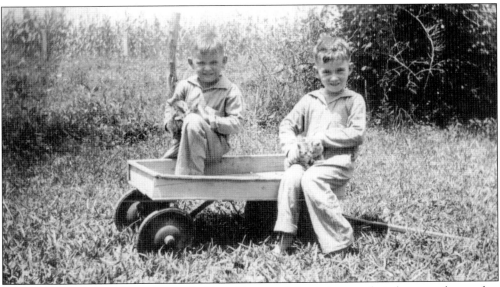

Twins Bill and Bob Alexander are holding kittens while sitting on their homemade wooden wagon, c. 1935. (Courtesy of Mr. and Mrs. Bill Alexander.)

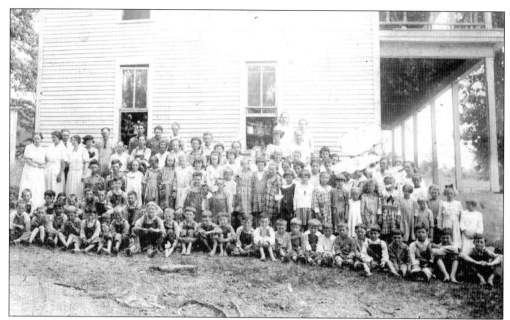

Paul Baskett attended Clear Springs School, which taught grades 1 through 10. Paul, fifth from left in the front row, sits with his first-grade class in this 1919 photograph. (Courtesy of Frances Million.)

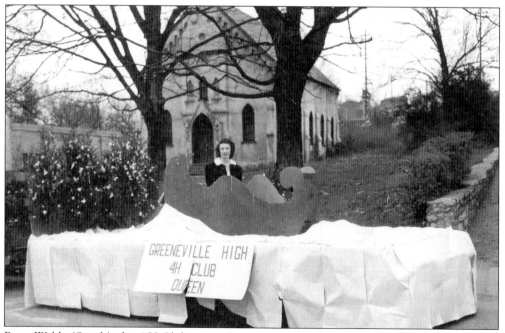

Patsy Wykle (Smith), the 4-H Club queen, is seen atop the Greeneville High School 4-H Club float in the 1949 Christmas parade. In the background, St. Patrick's Catholic Church on College Street is in view. This beautiful church was completed in 1879, with Pres. Andrew Johnson in attendance at the dedication. The church was renovated in 1906 but fell into disrepair in later years and was razed in 1950. (Photograph courtesy of Mr. and Mrs. Robert Smith; church information courtesy of Mrs. Gary Greenway.)

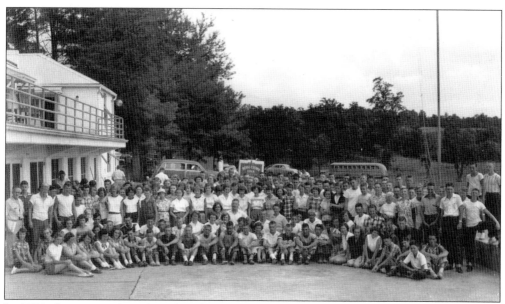

In 1954, this group of youth gathered at the Clyde B. Austin 4-H Camp. The camp provided a week of fun with crafts, swimming, square dancing, and camaraderie. (Courtesy of Leo and Jean Birdwell.)

Many young ladies and gentlemen gathered at Hilltop to celebrate the birthday of Gregg Jones. This 1962 photograph includes Jackie Roberts, Claudia Roberts, Sally Jones, Nancy Hale, Libby Gott, Benna Seneker, Gary Johnson, Miles Marshall, Brenda Gaby, Beth Saville, Linda Rollinson, Mike Ricker, Gregg Jones, Terry Self, Ralph Najar, and other, unidentified guests. (Courtesy of Beth Saville.)

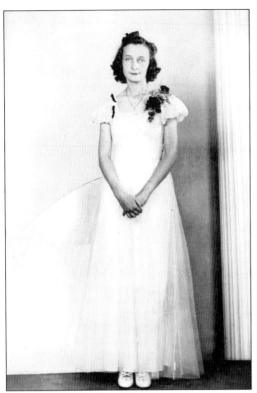

In 1940, Wanda Royall was dressed to the nines for her senior banquet. She was a graduate of Greeneville High School. (Courtesy of Wanda Royall Sauceman.)

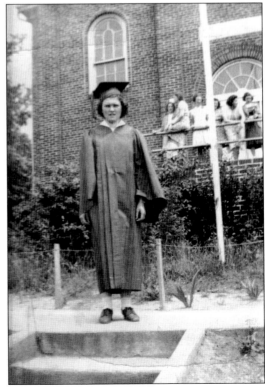

Helen Smith (Southerland) stands in front of Doak High School on the day of her graduation in 1939. (From the collection of Mr. and Mrs. Arthur Southerland.)

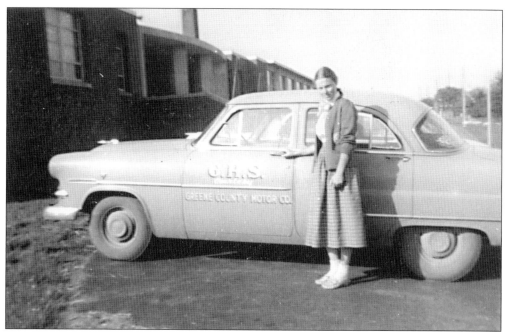

Eleanor Eacret (Mosca) stands beside the driver's education Ford at Greeneville High School. In 1955, Charles Thorpe was the driver's education teacher as well as the high school vice principal. Charles Earnest was the principal. (Courtesy of Eleanor Eacret Mosca.)

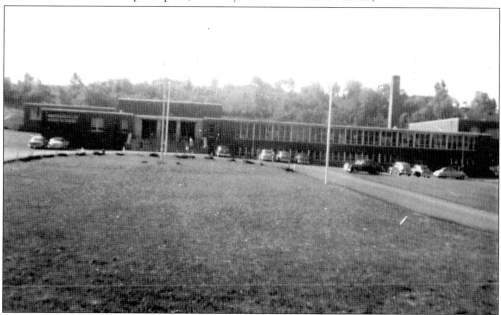

Greeneville High School on Tusculum Boulevard is pictured here as it appeared in 1955. When it opened in 1952, Gov. Frank Clement was on hand for the dedication. There were around 550 students in grades 9 through 12. The Youth Builders of Greeneville, Inc., were instrumental in making this new high school a reality. In 1936, when the high school was located on Main Street, they became known as the Devils. Prior to that time, they were the Warriors. (Courtesy of Eleanor Eacret Mosca.)

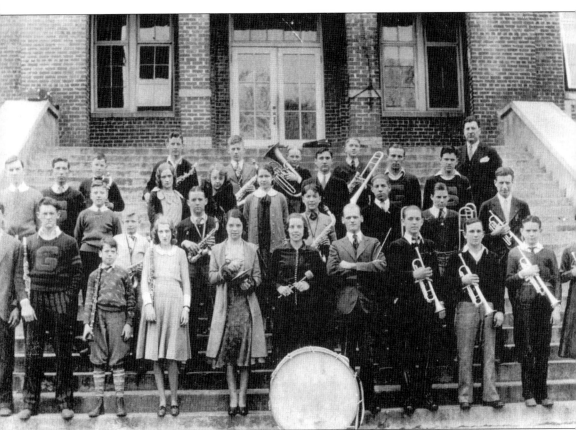

The Greeneville High School band stands in front of the old high school in 1934. Not everyone was identified, but known faces are Mayford Collette, Jack Armitage, Margarite Roberts, Mary Will Easterly (Hogan), Elizabeth Wilson (Tallent), Edgar Fenstemacher, George Kennon, Tom Austin, Dale Mysinger, O. C. Armitage, Maurine Reynolds, Josephine Janynes (Mills), Roland Myers, Charles Lovette, Joe Maupin, Mac Sentelle, Wallace Earnest, and Robert Bell, director. (Courtesy Louise Orr.)

The Greeneville High School girls' basketball team is pictured here in 1934. Included from left to right are (first row) Rena Mae Cutshaw (Morrow), Hilda Snyder, Mae Britton, Roberta Jones, Katherine Simpson, Dorothy Jean Wayland (Smith), and Ina Myers; (second row) Volena Harrison (Foshee), Eleanor Easterly, Barbara Willis (Alexander), Kit Doughty (Hickerson), Agnes McAmis, Aline Solomon, and Mildred Morrell; (third row) Dorothy Hardin (Mayo), Elizabeth Britton (Reaves), coach Elmer Solomon, Frances Bernard (Overall), and Emily Doughty (Bray). (Courtesy of Louise Orr.)

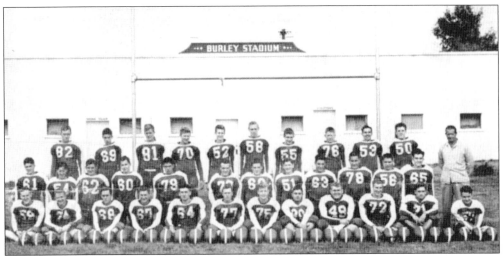

The 1949 Greeneville High School football team consisted of, from left to right, (first row) Keith Pierce, Buddy Saulsbury, Willie Wilson, Llewellyn Sexton, Richard Snapp, A. L. "Ducky" Duckworth Jr., Charles Malone, Jimmy Demo, Gerald Solomon, Gene Cochran, Jimmy Dugger, and Johnnie Wisecarver; (second row) Bobby Frye, Gordon Gray, Joe Sams, Allen Bradford, Jack Laughters, Charles Reed, A. J. Harmon, Edward Crum, Junior Williams, Charles Rader, John Holloman, Hayden Britton, and coach Ty Disney; (third row) Edward Saulsbury, Bobby Wells, Curtis Aldridge, Frank Leming, Richard Ferguson, Charles Taylor, Billy Starnes, Eddie Dunham, Harmon Long, and Jimmy Banner. (Courtesy of Mr. and Mrs. Robert Smith.)

Homecoming is always a popular event at Greeneville High School. This 1967 photograph shows, from left to right, Terry Wexler, Judy Bryant, Mark Benko, Pam Hankins (Benko), ? Wilhoit, unidentified, Kathy Kennon (Nunnally), Janie Waddell (Hoffman), Benny Rippitoe, Ellen Milligan (Capito), Steven Connell, Jean Horne, Alex Broyles, and Barbara Bewley (Clanton). (Courtesy of Mrs. Alex C. Broyles Jr.)

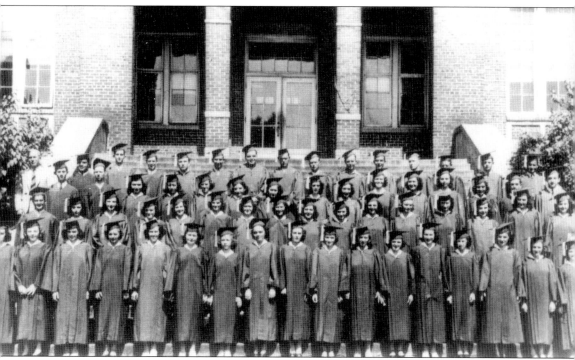

The class of 1941 stands in front of the old Greeneville High School. Many students had attended first grade there, which was held in the basement. They then went on to the Roby Primary School until they came back to the high school for ninth grade. (Courtesy of Mrs. Harold Dobson.)

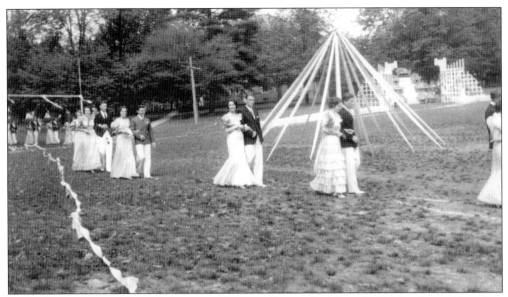

Since the 1930s, a popular social event in Greeneville was the Maypole Celebration at Tusculum College. Each high school in the area sent representatives to the dance. These young ladies and gentlemen are seen promenading across the grounds of the college. (Courtesy of Mrs. Chris Saville.)

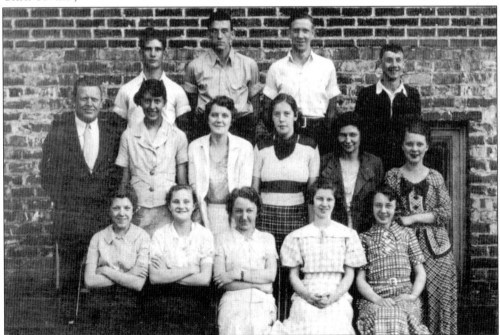

In 1935, the juniors at Doak High School appear to be happy to pose for this class photograph. Included are Carlos Cordova, Celestine Crum, Cletis Holder, Charles Love, Henry Sentelle, Clara Bell Humphreys, Kate Kelly, Ruth Anderson Lusky, Dot Lane Davis, Virginia Williams Edwards, Gertrude Jaynes Herrin, Gertrude Johnson, Lenna Jaynes McAmis, Margaret Simpson Gaut, and Frankie Jaynes Byrd. Louise Taylor Thornton is not pictured. (Courtesy of Mr. and Mrs. William King Gaut.)

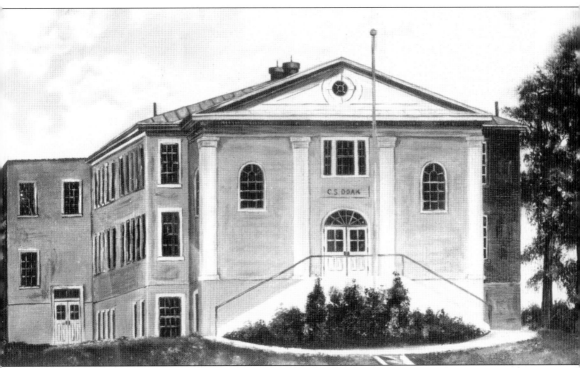

Until the early 1920s, the three-room Weed Hill School was the Tusculum area's only school for lower education. At this time, there was a growing need for continued education. Concerned parents unified to start a larger building, which was completed in 1925. There were several major contributors to this building. Charlie Doak was coaxed into giving $1,000 if they named the school after him. Will Russell, the father of 12 children, gave $500, Tom Dugger donated $500, and Jim Park gave $400. Many others contributed, including Rufe Taylor, also the father of 12 children, and Will Simpson. Myrtle Dobson collected chickens and eggs for seed money. There were also many donations during the construction for labor and equipment. When Weed Hill was razed to make way for Doak High School, students stayed home for the year. This rendering shows Doak High School after the additions (far left and far right), which were added around 1930. (Courtesy Mr. and Mrs. William King Gaut.)

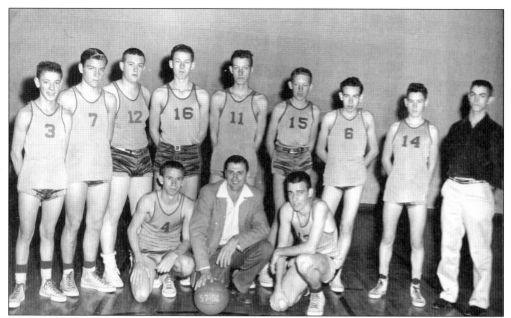

The 1957–1958 basketball team from Doak High School is pictured here. Jimmy Southerland is fourth from the left. The uniforms have certainly changed since then! (From the collection of Mr. and Mrs. Arthur Southerland.)

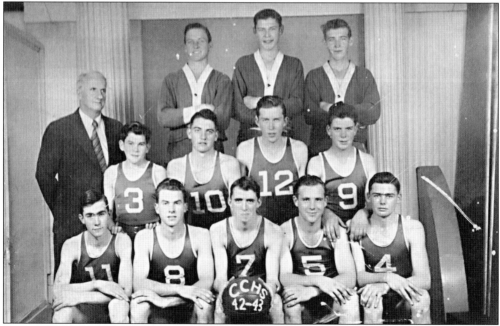

The 1942–1943 basketball team from Camp Creek probably would have won the tournament that year if they had gone. They qualified, but because of gas rationing they could not make the trip. The players, pictured from left to right, are (first row) Raven Hopson, J. H. Parman, Willis Bowman, Don Broyles, and captain C. L. Myers; (second row) Guy Dean Parman, Guy Myers, Paul Busher, and Jack Bowman; (third row) Clyde Myers, Glenn Lyons, J. H. Miller. The coach at far left is J. S. Irvin. (Courtesy of Clark Parman.)

Three

MILITARY

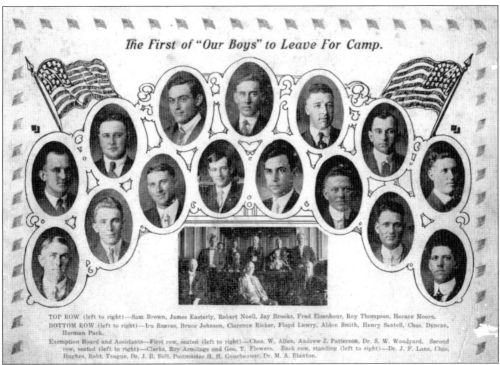

The First of "Our Boys" to Leave For Camp.

TOP ROW (left to right)—Sam Brown, James Easterly, Robert Noell, Jay Brooks, Fred Eisenhour, Roy Thompson, Horace Moore.
BOTTOM ROW (left to right)—Ira Reaves, Bruce Johnson, Clarence Ricker, Floyd Lowry, Aldon Smith, Henry Sentell, Chas. Duncan, Herman Pack.
Exemption Board and Assistants—First row, seated (left to right)—Chas. W. Allen, Andrew J. Patterson, Dr. S. W. Woodyard. Second row, seated (left to right)—Clerks, Roy Armitage and Geo. T. Flowers. Back row, standing (left to right)—Dr. J. F. Lane, Chas. Hughes, Robt. Teague, Dr. J. B. Bell, Postmaster H. H. Gouchenhour, Dr. M. A. Blanton.

This flyer produced in the early 1940s is self-explanatory. Pictured from left to right are (top row) Sam Brown, James Easterly, Robert Noell, Jay Brooks, Fred Eisenhour, Roy Thompson, and Horace Moore; (bottom row) Ira Reaves, Bruce Johnson, Clarence Ricker, Floyd Lowry, Aldon Smith, Henry Sentell, Charles Duncan, and Herman Pack. The inset photograph includes the Exemption Board and assistants. Seated from left to right are (first row) Charles W. Allen, Andrew J. Patterson, and Dr. S. W. Woodyard; (second row) clerks Roy Armitage and George T. Flowers; (third row) Dr. J. F. Lane, Charles Hughes, Robert Teague, Dr. J. B. Bell, Postmaster H. H. Gouchenhour, and Dr. M. A. Blanton. (Courtesy of Wanda Royall Sauceman.)

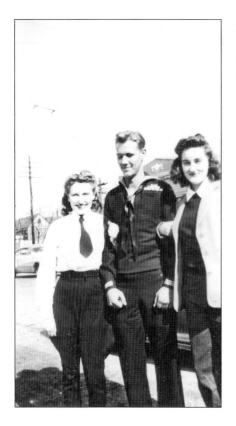

Wesley Ford was on leave from the navy in this late-1950s photograph. He has Jean Broyles to his right and Pat McMannon to his left. (Courtesy of Mrs. Alex C. Broyles Jr.)

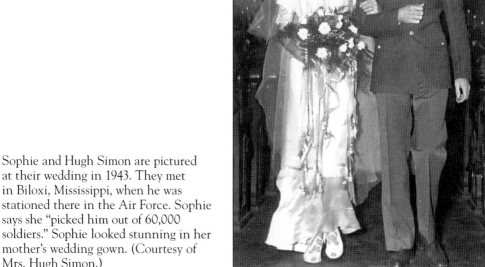

Sophie and Hugh Simon are pictured at their wedding in 1943. They met in Biloxi, Mississippi, when he was stationed there in the Air Force. Sophie says she "picked him out of 60,000 soldiers." Sophie looked stunning in her mother's wedding gown. (Courtesy of Mrs. Hugh Simon.)

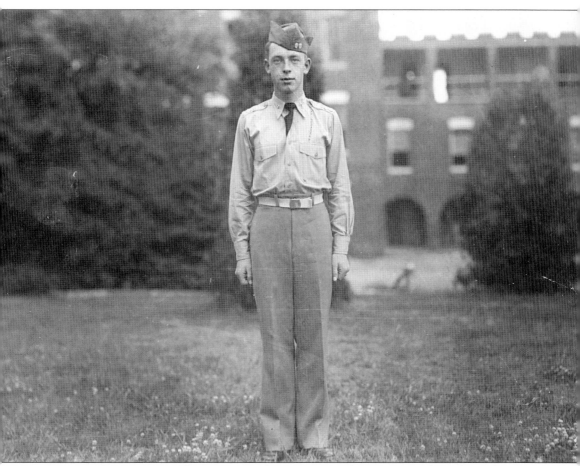

Alex C. Broyles Jr. is pictured here in 1944 at the Tennessee Military Institute during his sophomore year. He went on to Georgia Tech and then to the army. He continued his education at Yale, where he learned Japanese and subsequently was assigned to the Criminal Investigation Division of the U.S. Army. (Courtesy of Mrs. Alex C. Broyles Jr.)

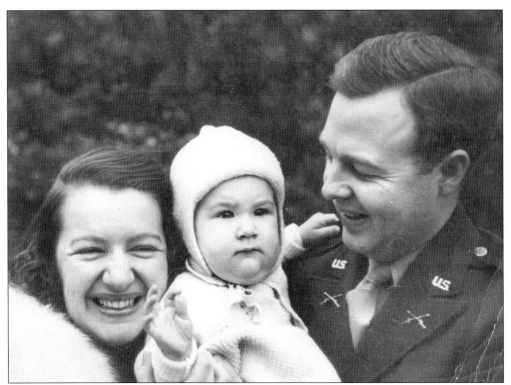

In 1942, John M. Jones was home on leave from the army before joining Merrill's Marauders. John served in the army from 1941 until 1945. He was awarded the Soldier's Medal for saving the life of a fellow marauder. He is pictured here with his wife, Arne, and their first of five children, John Jr. (Courtesy of the John M. Jones family.)

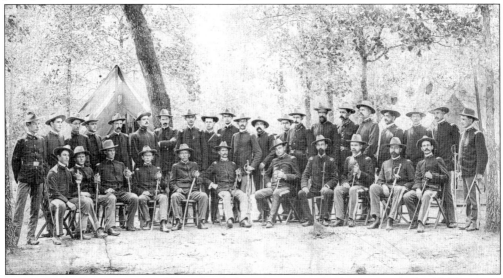

Dr. Frank P. Robinson is pictured here, fourth from the right in the first row, with the 6th Tennessee Volunteer Infantry in 1898. While serving in Puerto Rico, the unit nicknamed themselves "The Immunes" since so many involved with the Spanish-American War died from disease. (Courtesy of Louise Orr.)

Charlie Colyer served in World War I in the army infantry. It is believed he served in Germany. (Courtesy of Eleanor Eacret Mosca.)

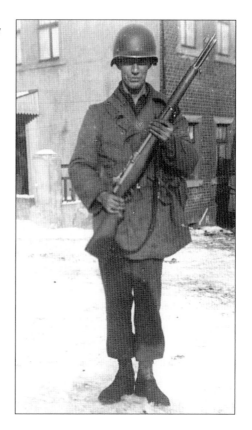

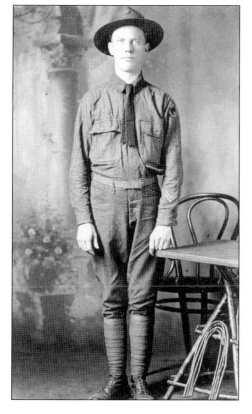

Walter Frederick "Jim" Colyer was in the army infantry in World War II. Upon his return from the war, he worked at the post office as a custodian. Each morning at 3:00 a.m., he would go to the train depot to pick up the mail to take to the post office for sorting and distribution. (Courtesy of Eleanor Eacret Mosca.)

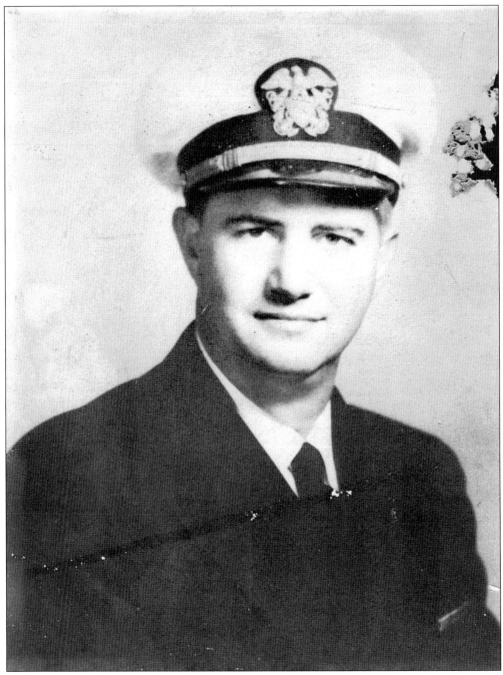

Forrest C. Orr served in the navy in the 1940s. He served in the Pacific and was in charge of a gun crew on the *W. S. Farish*, the largest oil tanker at that time. (Courtesy of Louise Orr.)

Frank P. Robinson III served in the Army Air Force. He was a night fighter pilot in World War II. Frank lost an eye during this time and subsequently was assigned to a tank unit for the Korean conflict. This photograph was taken in the mid-1940s. (Courtesy of Louise Orr.)

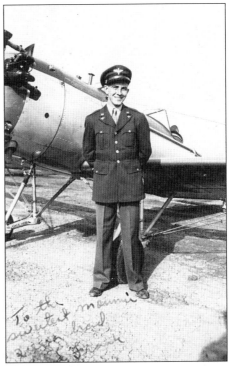

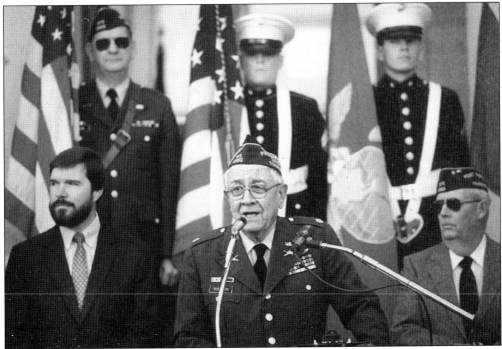

As a veteran of World War II and Korea, Frank P. Robinson III (center) was the guest speaker at a Veteran's Day gathering in this 1970s photograph. During his military career, he was awarded the Distinguished Flying Cross, the Air Force Medal, the Soldier's Medal, and the Purple Heart. (Courtesy of Louise Orr.)

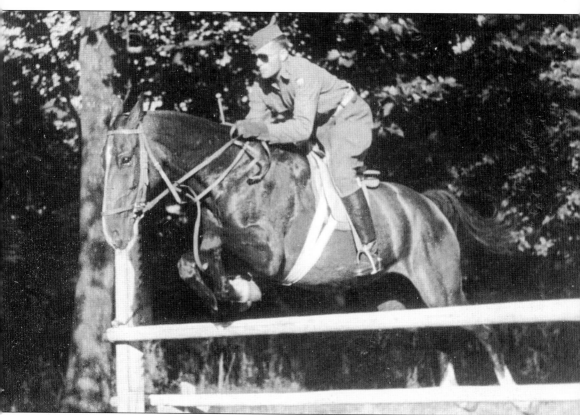

At the conclusion of World War II, Col. Elba Bowen was stationed in Stuttgart, Germany, for the next two years. Along with receiving the World War II Riders Medal, he received many awards for his equestrian capabilities. (Courtesy of Mrs. Elba Bowen.)

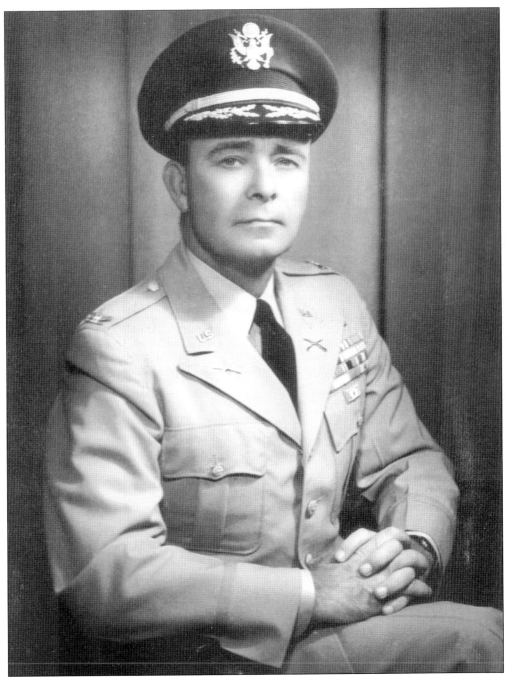

Col. Elba Bowen is pictured here in the 1960s. He served in the army infantry for 30 years. During his service, he participated in World War II, Korea, and Vietnam. Highly decorated, a few of his honors included the Distinguished Service Medal, Silver Star, Legion of Merit, Bronze Star, and Purple Heart. Colonel Bowen had the unique opportunity during his military career, aside from the wars, to experience colorful times such as tiger hunting with the Shah of Iran, being the guest of honor at an Afghan tribal ritual, and escorting Bob Hope and Marilyn Monroe during their visits with troops. (Courtesy of Mrs. Elba Bowen.)

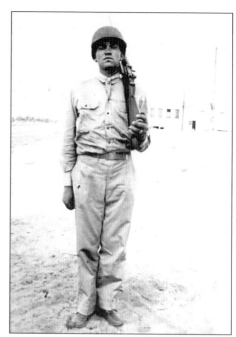

Above left: Charles Rebert Smith, born in 1925, served in World War II and received the American Theater Ribbon, EAME Theater Ribbon with two Bronze Stars, the World War II Victory Medal, and Good Conduct Medal.

Above right: John Robert Smith Jr., born in 1920, was a veteran of World War II. He was injured on Thanksgiving Day 1944 while stationed in Belgium, and thus he received a Purple Heart.

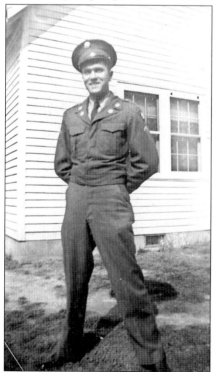

Doyle Andrew Smith, born in 1927, served in Korea as a medical technician. He received the Bronze Service Star and United Nations Service Medal. The fourth brother in the Smith family also served in the military. Lyndel Paul Smith, born in 1939, was stationed in Bangkok, Thailand, for the majority of his service. (From the collection of Mr. and Mrs. Arthur Southerland.)

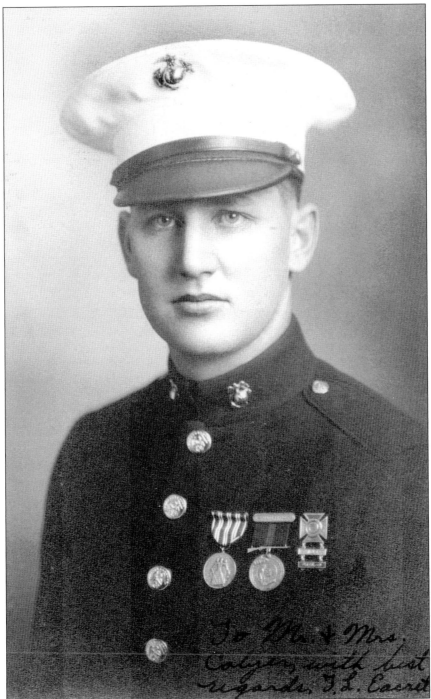

Theo Leland Eacret is pictured here in 1935 in his Marine uniform. He sent this picture to the parents of his girlfriend and future wife, Glenna. Theo joined the Marines in 1928 and served with the expeditionary force in Nicaragua, where he was involved in the military surveillance for the construction of the Panama Canal. He also served on the USS *Pennsylvania*, the USS *Oklahoma*, and the USS *Arkansas* with tours in the Mediterranean. (Courtesy of Eleanor Eacret Mosca.)

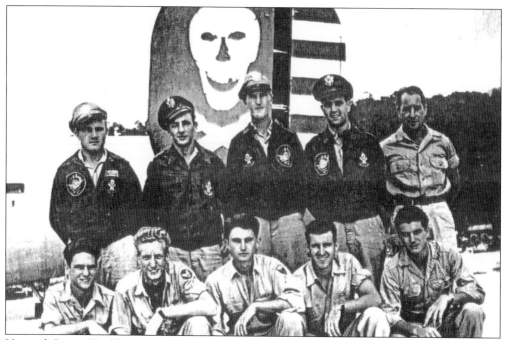

Howard Orton "Buddy" Lane is in the center of the first row of this 1942 picture. The "Jolly Rodger" can be seen behind this fine group of Air Force personnel, which took them on many maneuvers in the Pacific. There were men from many different states in this outfit, several of whom Buddy is still in touch with. (Courtesy of Howard O. "Buddy" Lane.)

Jacob Southerland, father of Arthur Southerland, is pictured here in 1898. He fought in the Spanish-American War. (From the collection of Mr. and Mrs. Arthur Southerland.)

Four

COMMUNITY

On May 19, 1953, Maxine Humphreys started a part-time job at WGRV Radio as a news reporter. She is pictured here in front of the microphone readying for her famous 12:30 news. Through time, Maxine has not only broadcast local news but has also served as bookkeeper for affiliate stations and done various other tasks taking her to full-time status. However, her first love is reporting the local news, which she continues to do daily. It is rumored that certain physicians will not schedule patients at 12:30 so they can listen in. The sponsorship of her daily news broadcast has been from Doughty Stevens Funeral Home (and Furniture Store in earlier years) and has continued through more than 53 years. She is a real dynamo in the industry and has received accolades for her reporting from across the nation. (Courtesy of WGRV Radio.)

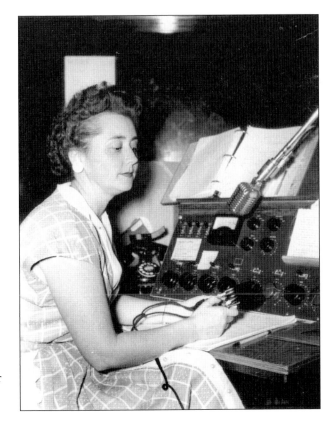

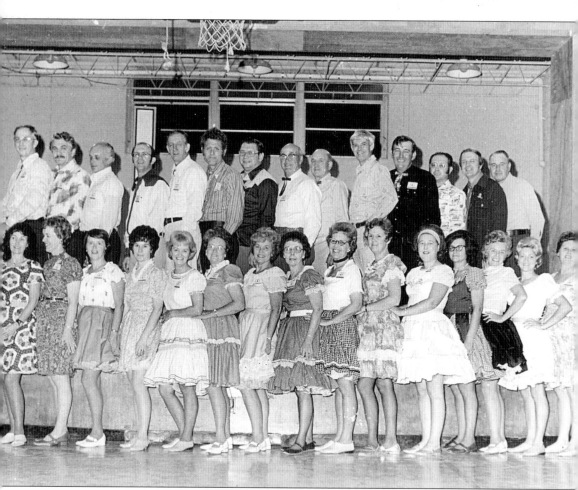

The Promenaders Square Dance Club, under the direction of caller Don Williamson, danced to their hearts' delight. They danced at various facilities in town including Eastview Recreation Center, the YMCA, and the Moose Club. Pictured here in 1976 from left to right are (first row) Norma Webb, Martha Lang, Nancy Snider, Jane Miller, Marie Bronson, Frances Baskett, Virginia Harrison, Harriet Brooks, Fawn Hayes, Audrey Graves, Bessie Key, Jackie Hall, Linda Massey, Jackie Ondrusek, and Mildred Williamson; (second row) Carlton Lang, Keith Webb, Jim Snider, J. D. Miller, Russ Bronson, Joe Alexander, Gus Ondrusek, Clark Harrison, Ed Cunningham, Bob Graves, Grover Hall, Gilbert Massey, Don Williamson, and Howard Holley. The Weavers Square Dance Club was a similar group led by caller Billy Joe Oliver and organized in 1963. (Courtesy of Frances Million.)

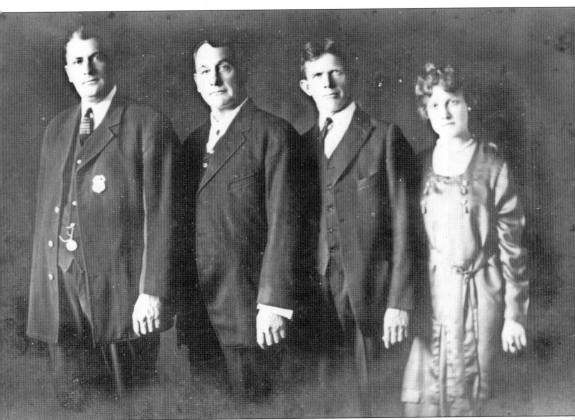

"The Quartet," as photographed *c.* 1920, consisted of, from left to right, Marion Laughters (chief of police), W. G. Butler, Hayes Hull, and Elsie Butler. The foursome sang for various gatherings around town and special occasions. In one instance, Hayes Hull was ill and was picked up in a white ambulance to get to the singing engagement. By coincidence, perhaps, one of the songs they sang was "On the Wings of a Snow White Bird." (Courtesy of Wanda Royall Sauceman.)

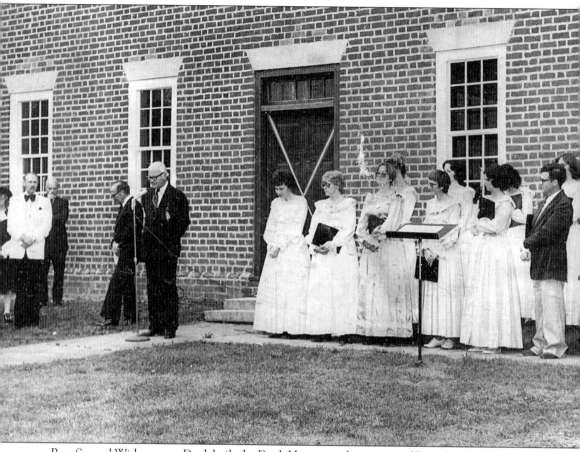

Rev. Samuel Witherspoon Doak built the Doak House, on the campus of Tusculum College, around 1830. Doak descendants occupied the house until the 1970s. It was then donated to Tusculum College. At this point, the Greene County Heritage Trust took on the task of restoring the house with the help of a grant from the American Revolution Bicentennial Administration and several other fund-raising efforts. Noted architect Everette Fauber directed the restoration. This 1970s photograph shows the dedication ceremony after the restoration. From left to right are an unidentified woman, Richard Doughty (in white jacket), Walter Dette (partially hidden behind Doughty), Col. Elba Bowen (president of Heritage Trust), Ambassador Kenneth Rush (guest speaker and ambassador to France), and the Tusculum choir. (Courtesy of Greeneville–Greene County Library, Lanthe Rush Campbell collection.)

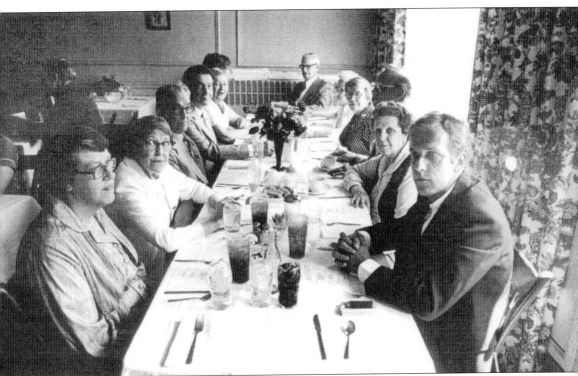

In 1884, the Grand Central Hotel was completed on Main Street. It had previously been the site of taverns and inns since the late 18th century. Over the years, it was owned and operated by two Greeneville families, the Doughtys and the Brumleys. During this time, the name changed to the Hotel Brumley. On Sunday, May 24, 1981, the last meal was served at the Hotel Brumley. Reservations were required, and the menu consisted of lamb, chicken fried steak, ham, fried mush (a house specialty), green beans, broccoli casserole, new potatoes, hot rolls, peach cobbler, and boiled custard. The owner of the hotel at the time was Eva Brumley Kenny, and, at age 85, she was present for the last meal. Shown in the photograph from left to right going around table are Joyce McLain, Grace McLain Mackey, Ralph McLain, Howard O. "Buddy" Lane, Marilyn Morrow Lane, Sam Lane, Wm. D. "Buck" Morrow, Alyn McLain Morrow, Jackie McLain Woodmore, H. Lee Hendrix, Madge McLain Hendrix, and John Hendrix. Subsequently the hotel underwent extensive renovations. (Photograph by Roger Hendrix, courtesy of the Nathanael Greene Museum.)

KNOW YOUR TOWN

When was Greeneville founded?
1783.
For whom named?
Nathaniel Greene.
When incorporated?
Approximately 1786.
Oldest record?
1796.
What is the population?
3,775.
What is the elevation of Greeneville at the Greene County Bank?
1529.
What is the City tax rate?
$1.40.
What is the assessed property valuation?
$3,702,180.
What per cent of value is property assessed?
Cash value.
How is the City assessment arrived at?
Market value.
What is the bonded indebtedness?
$415,500.
How many miles of paved street?
Seven.
How long was paving guaranteed?
Five years.
What form of City Government?
Elective.
What term are City officers elected?
Two years.
Salary of Mayor?
$50.
Salary of Aldermen?
$24.
Salary of Recorder?
$1800.
How many members of Water Commission?
Three.
How selected?
Elected by popular vote.
For what term?
Three years.
What is the salary of a Water Commissioner?
$100 per year and free water.
What is the rate charged for water?
25c per thousand gallons.
Salary of Superintendent of Water Works?
$1800.

Are children of any denomination received at Orphanage?
Yes.
How is Orphanage supported?
Holston Conference M. E. Church, South.
How many employed at Brown Manufacturing Co?
57.
How many employed at Loudon Hosiery Mills?
150.
How many employed at Hood Chair Co.?
120.
How many employed at Lamons Wagon Co.?
22.
How many warehouses for sale of tobacco?
6.
How many pounds sold here last year?
4,176,354.
Average price of tobacco here last year?
$31.52 (highest average in United States).
What is the official name of our Library?
Carnegie.
How is Library financed?
Town and County.
How many Churches in the city?
Fifteen white; four colored.
How many Banks in Greeneville?
4.
Total Capital of said Banks?
$260,000.
Annual business of local post-office?
$32,000.
Salary of Post Master?
$2900.
How many rural routes from this office?
14.
How often does Federal Court meet in Greeneville?
Twice per year.
Salary of County Court Clerk?
$5,000.
Salary of Trustee?
$5,000.
Salary of Sheriff?
$5,000.
Salary of Register?
$5,000.
Salary of Circuit Court Clerk?
$1,200.
What is our State and County tax rate?

This item of interest was printed in *The Greeneville Sun* in 1922. (Courtesy of the Nathanael Greene Museum.)

376.
How many teachers in High School?
6.
How many teachers in Grammar School?
17.
How much are teachers paid per month?
Average $85.
How many pupils in colored school?
200.
Where do the colored children attend school?
Greeneville College.
When was Greeneville College founded?
(Now Tusculum); 1794.
What year did Andrew Johnson come to Greeneville?
1826.
What city offices did he hold?
Alderman, mayor.
What year was he elected Vice-President?
1864.
What year did he become President?
1865.
What year did Johnson die?
1875.
Who owns the National Cemetery where he is buried?
United States Government.
What is the official name of the above cemetery?
Andrew Johnson National Cemetery.
How was property acquired?
Given by Andrew Johnson heirs.
Who founded the Greeneville Orphanage?
Mrs. Elizabeth Wiley.

50 years.
What is the rate charged per kilowatt?
10c. and 8c.
Is the rate higher here or at Johnson City?
Same.
Name of Local Representative of Tenn Eastern Electric Co.
O. S. Mullen.
What should be done to him?
Complimented.
How many Civic Clubs in town?
Three.
Who is President of the Rotary Club?
C. W. Allen.
Who is secretary of Rotary Club?
J. H. Rader.
How many members has Rotary Club?
33.
How many Dry Goods Stores in Greeneville?
13.
How many wholesale houses in Greeneville?
2.
How many garages in Greeneville?
7.
How many Drug Stores in Greeneville?
4.
Who owns the Andrew Johnson Tailor Shop?
State of Tennessee.
How will it be maintained?
State of Tennessee.
How was it acquired?
By State Purchased.

(The above contest was put on by the Greeneville Civitan Club among its members, and Civitan W. H. Doughty has offered a prize for the most correct set of answers. The papers are being graded and the prize-winner will be announced later. The Civitan Club is to be congratulated on compiling this useful list of statistics which every Greenevillian should know. Cut them out and file them; you will want to refer to them many times.—EDITOR).

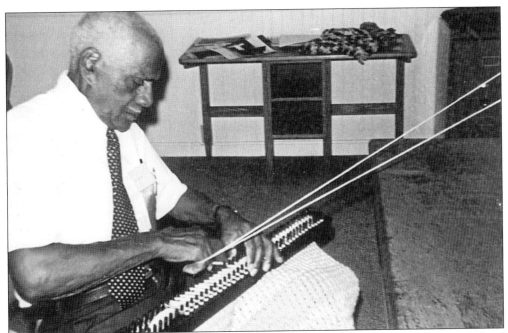

The Roby Fitzgerald Adult Center is a multipurpose center providing services to the elderly of Greeneville and Greene County. These services include transportation, natural support services, and leisure-time activities designed to promote the well-being of senior citizens. Activities and workshops offered range from arts and crafts to computer use to line dancing. In this 1960s photograph, Mr. Scott is honing his skills at peg knitting. (Courtesy of the Roby Fitzgerald Adult Center.)

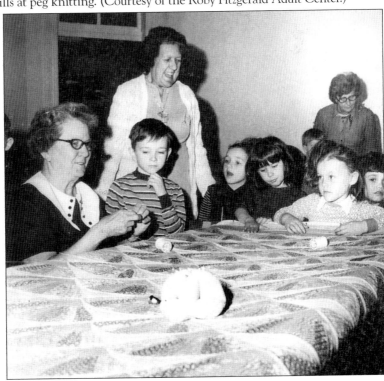

Schoolchildren are watchful as seniors at the Roby Fitzgerald Adult Center are teaching them how to quilt. This photograph was taken c. 1960. (Courtesy of the Roby Fitzgerald Adult Center.)

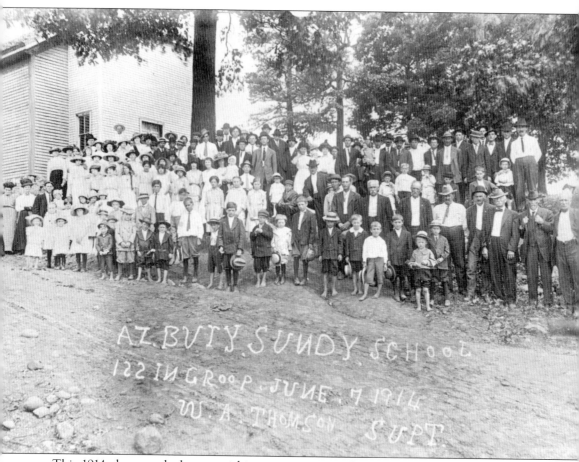

This 1914 photograph shows parishioners posing outside a Greene County church. Notice practically everyone is either wearing or holding a hat and many of the children are barefoot. (Courtesy of Jerry Hankins.)

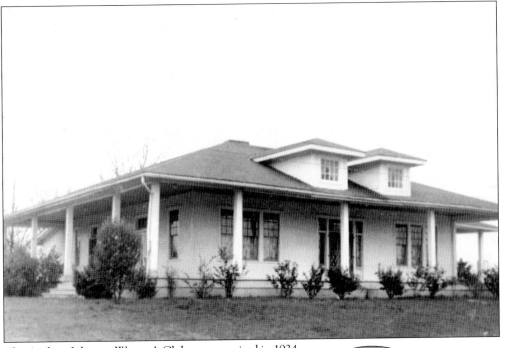

The Andrew Johnson Women's Club was organized in 1934 as a combination of the Cherokee Club, the Mother's Club, and the Junior Mother's Club. The club participates in many civic projects and activities. Its objective is to contribute to the welfare of the community by promoting common interests in education, philanthropy, public welfare, moral values, civics, and fine arts. The Andrew Johnson Clubhouse appears in this 1962 photograph. The structure was built in 1923 and leased to the Greeneville Golf and Country Club. During Mrs. Clyde Austin's term, 1934–1936, the building was purchased from Mrs. Jay Milligan by the club for $3,500. It took two years to pay the debt. The clubhouse is used for various social events as well as club meetings. (Courtesy of the Andrew Johnson Women's Club.)

The Andrew Johnson Women's Club honored Mrs. Clyde B. Austin in 1959 during their silver anniversary review. The scrapbook that year was dedicated to Mrs. Austin. (Courtesy of the Andrew Johnson Women's Club.)

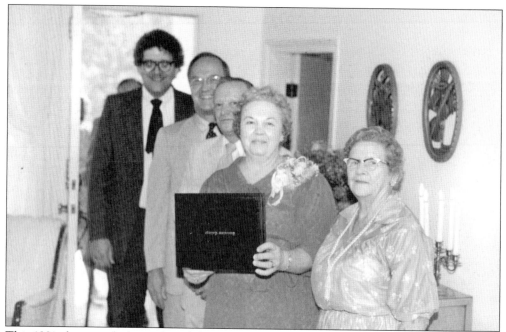

This 1981 photograph shows, from left to right, Thom Shuman (director of alumni and church relations at Tusculum College), Dr. Earl Mezoff (president of Tusculum College), Harold Dobson, Margaret Dobson, and Myrtle Dobson. Harold and Margaret Dobson were presented with a certificate from the college for many years of faithful service. (Courtesy of Mrs. Harold Dobson.)

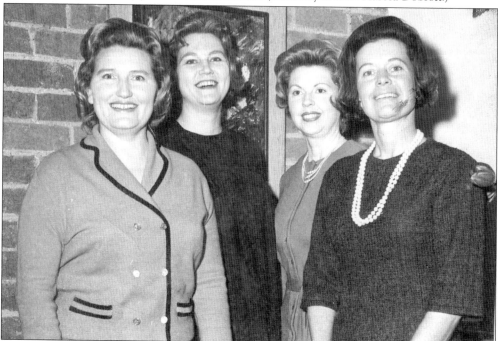

In 1965, these ladies stop to smile for a publicity photograph while planning a fund-raiser for the Youth Builders' arts league. Pictured from left to right are Mrs. Alex C. Broyles Jr., Mrs. Bill Bowman, Mrs. Shumann Brewer, and Mrs. Nat Coleman. (Courtesy of Mrs. Alex C. Broyles Jr.)

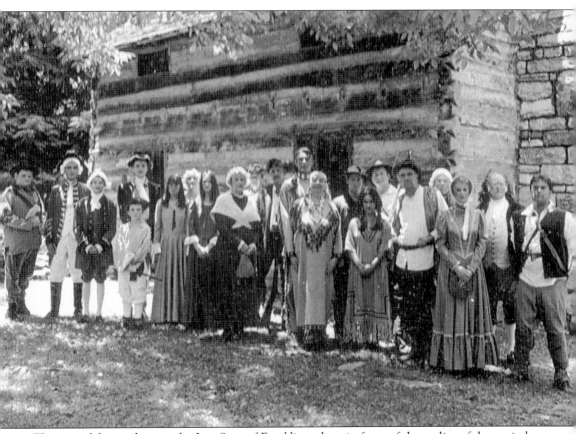

The cast of the production the *Lost State of Franklin* gathers in front of the replica of the capitol building on College Street. The play was written by Robert Orr and directed by Louise and Robert Orr around 1980. (Courtesy of Louise Orr.)

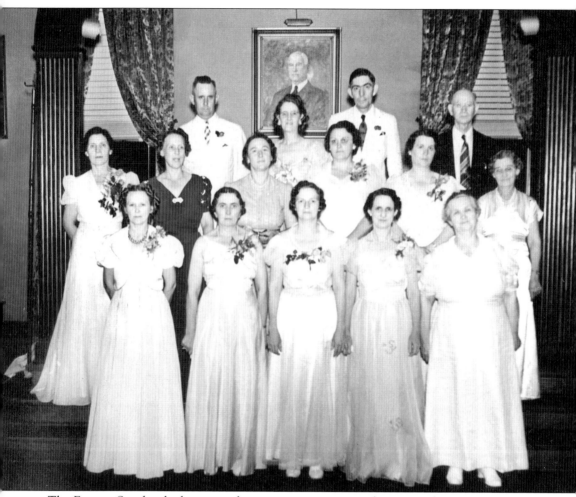

The Eastern Star has had many endearing ceremonies over the years. This 1934 photograph includes Luster Broyles (in the dark dress), Bessie Love Hawk (far right, second row), and Youla Broyles (third from left, second row). (Courtesy of Gertrude Dodd.)

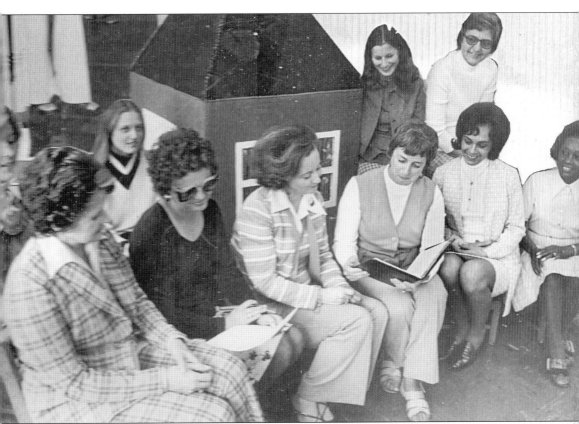

The Youth Builders of Greeneville, Inc., was founded in 1946. Their objective was, and still is, "to promote the welfare of children and youth in home, school, church, and community; to contribute needful service to the community as a whole." The first president of Youth Builders was Mrs. S. J. Milligan. This 1975 photograph shows the preschool committee as it met with teachers to discuss needs of youth. Pictured from left to right are (first row) Mrs. George Oden, Mrs. Ned Sanders, Mrs. Howard McNeese, Mrs. Harold Patton, Mrs. Ray Vaughn, and Mrs. Cecil Mills (teacher); (second row) Mrs. Bob Bilbo, Mrs. Rick Hamilton, Mrs. John Slater (teacher), and Mrs. Pete Linebarger (teacher). (Courtesy of Nathanael Greene Museum–Youth Builders collection.)

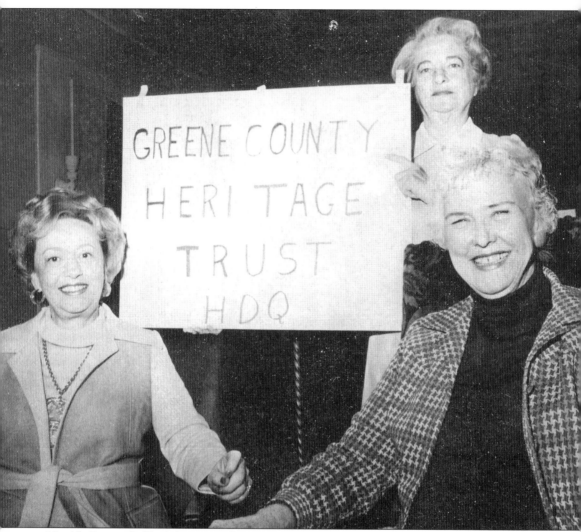

Matilda Bowen (left), Helen Cottrell (center), and Alice Murray (right) pose with their banner in the late 1970s indicating the Heritage Trust headquarters. (Courtesy of Mrs. Elba Bowen.)

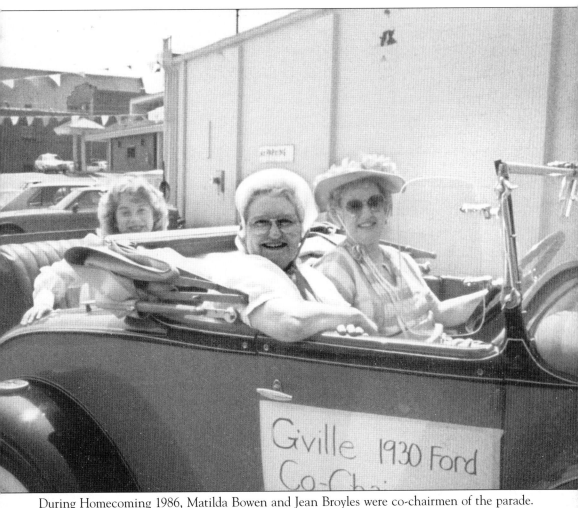

During Homecoming 1986, Matilda Bowen and Jean Broyles were co-chairmen of the parade. Matilda is behind the wheel, while Jean's granddaughter, Mary Jean Broyles, is in the rumble seat. (Courtesy of Mrs. Elba Bowen.)

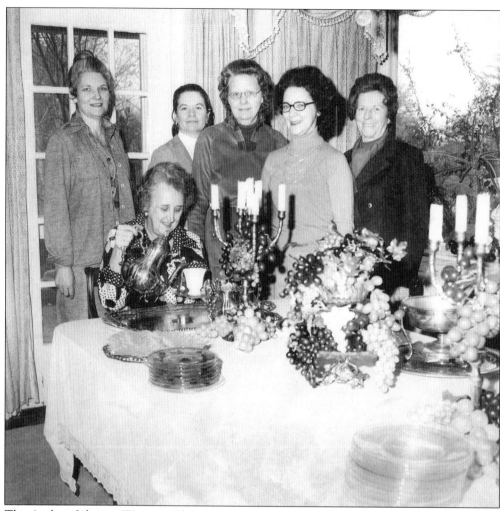

The Andrew Johnson Women's Club frequently serves tea to its membership. Included in this 1970s photograph at the Andrew Johnson Clubhouse are Mrs. Charlie Justis, Mrs. Fred Serral, Dora Carter Jones, Mrs. Royall Spees, and Mrs. Luke Ellenburg. (Courtesy of Mrs. Alex C. Broyles Jr.)

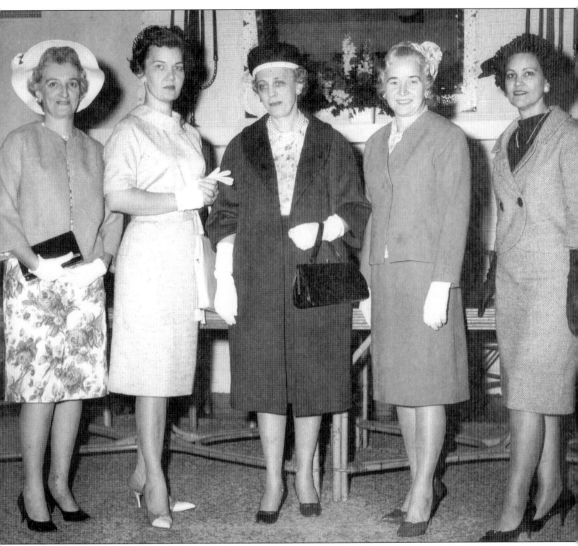

In 1962, the Andrew Johnson Women's Club sponsored a Vogue Sewing Contest. Seen here from left to right are Mrs. William Rawls, Mrs. Robert Park (second place), Mrs. Julian Alter (first place), Mrs. O. M. Clemmer (third place), and Mrs. Byron Sites. Mrs. Alter represented the club at the district convention's sewing contest. (Courtesy of the Andrew Johnson Women's Club.)

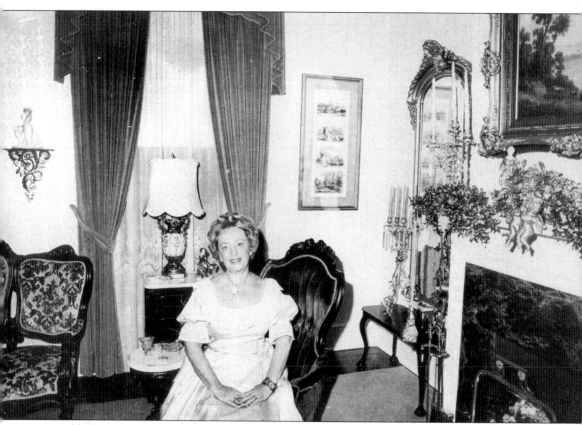

Matilda Bowen poses in period attire at the home of Margarite and Walter Dette. Matilda was a hostess at the Dette home during a Tour of Homes fund-raiser for the renovations at the Doak House in Tusculum. (Courtesy of Mrs. Elba Bowen.)

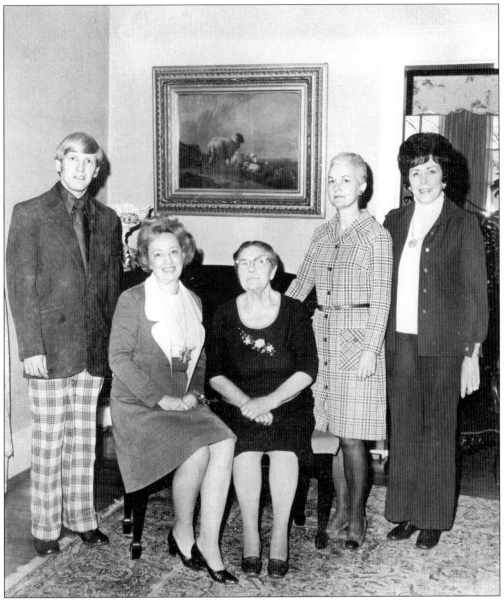

The Greeneville Arts Council is a nonprofit community organization whose purpose is to promote and stimulate interest in all the fine arts, with an emphasis on the visual arts. They provide scholarships for promising young artists and provide the community with an exposure to the visual arts. Posed in this late-1970s photograph from left to right are Haskell Fox, Matilda Bowen, Felice Austin, Mary Alice Dillard, and Gloria Rachmacey. They had been planning an Arts Council fund-raiser in Austin's home. (Courtesy of Mrs. Elba Bowen.)

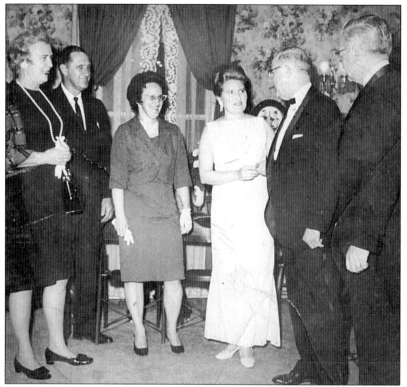

A Community Concerts fund-raiser was held in the early 1960s at the home of Mr. Richard Doughty. Included in this photograph are Alice Murray, Jean Broyles, Dr. Haskell Fox, and Mr. David Rhea. (Courtesy of Mrs. Alex C. Broyles Jr.)

These three lovely ladies are doing a dress rehearsal for a fund-raiser for the Andrew Johnson Women's Club. In this c. 1975 photograph are, from left to right, Mrs. A. Clarence Broyles, Mrs. E. B. Smith, and Mrs. Lawrence Reynolds. (Courtesy of Mrs. A. Clarence Broyles Jr.)

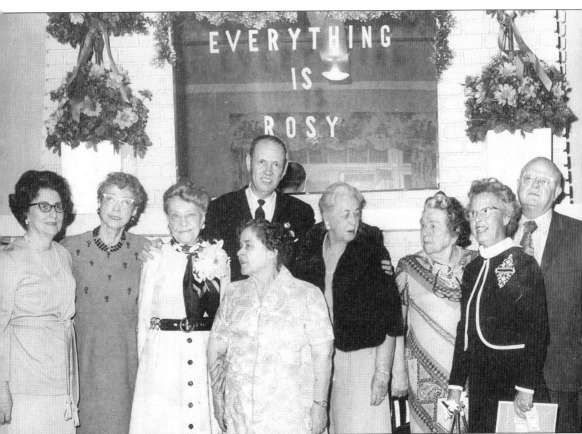

In the 1940s, Greeneville residents began attending concerts sponsored by the Community Concerts Association. Pictured at one such performance from left to right are Edith Crumley, Dorothy Sanders, Edith Susong, Mr. Richard Doughty, unidentified, Mrs. Raymond Rankin, Josephine Brabson, unidentified, and Dr. Haskell Fox. (Courtesy of Mrs. Alex C. Broyles Jr.)

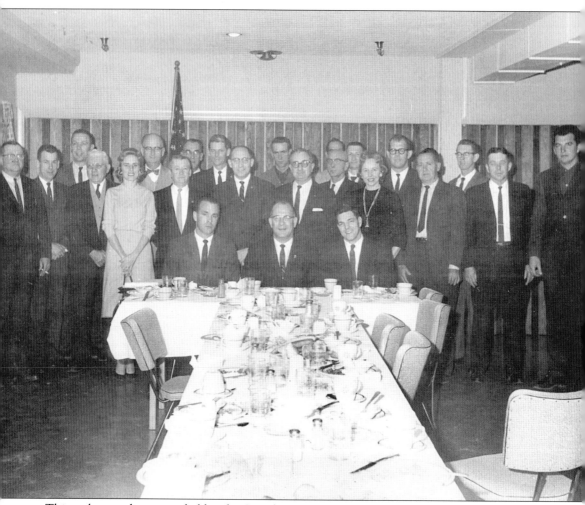

This real estate dinner was held at the Camelot Room at King Arthur's Court in the early 1960s. Among the first female real estate agents were Dot Looney (Alexander), fifth from left, and her sister, Donell Looney (Scarboro), sixth from right. Other agents, city officials and businessmen present include Mayor Earl Smith, David Love, Bill Bowman, Billy Williams, Ross Renner, Lloyd Saulsbury, Charley Justis, Phil Conway, Glenn Renner, John Cartwright, Hadley Carter, Wayland Mays, and Joe Bryant. (Courtesy of Mr. and Mrs. Bill Alexander.)

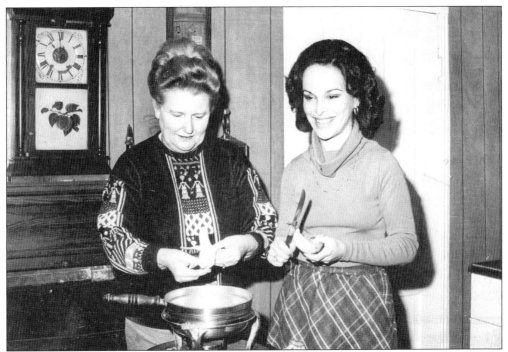

Mrs. Alex C. Broyles Jr. and Mrs. Clyde Austin III prepare bananas Foster for a Youth Builders fund-raising event in 1978. (Courtesy of Mrs. Alex C. Broyles Jr.)

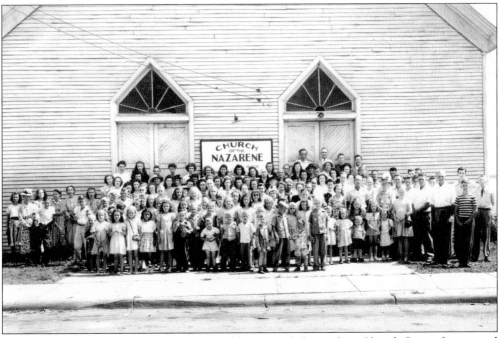

This is the last known image taken of the old tabernacle located on Church Street. It was used by several different congregations. This picture was taken on Easter Sunday 1948, when it was known as the Church of the Nazarene. After this congregation built a new church on Unaka Street in 1949, the tabernacle was demolished. (Courtesy of Eleanor Eacret Mosca.)

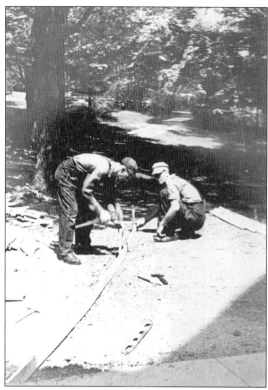

Arthur Southerland worked at Tusculum College for 35 years. He is seen here, on the left, with Walter Taylor as they build a walkway at the college in 1950. Arthur did whatever maintenance came up, including roofing, plumbing, and electrical work. (From the collection of Mr. and Mrs. Arthur Southerland.)

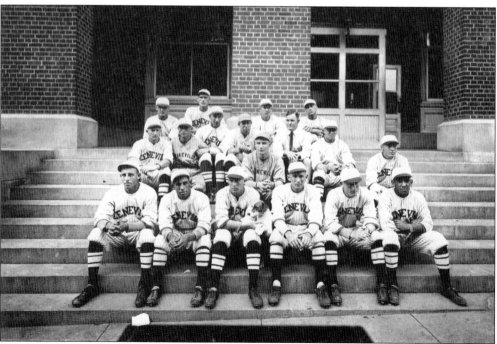

The Burley Cubs are pictured here around 1925. Sam Alexander, their manager, is at the very top. Mayor John Bernard is toward the back, without a uniform. Their original playing field was next to the current Greeneville High School. (Courtesy of Mr. and Mrs. Bill Alexander.)

Five

PLACES

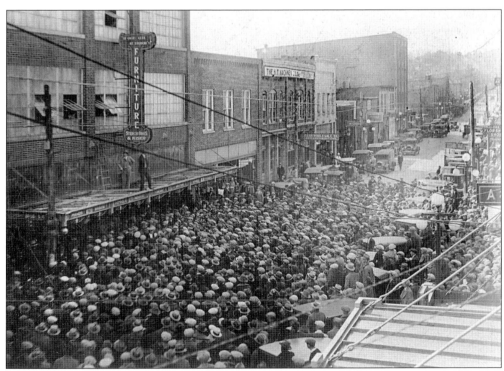

Around 1910, a crowd assembled for the drawing of a new car that was given away by Waddell Hardware and other merchants. W. C. Waddell Sr. can be seen on top of the overhang. (Courtesy of Mrs. Chris Saville.)

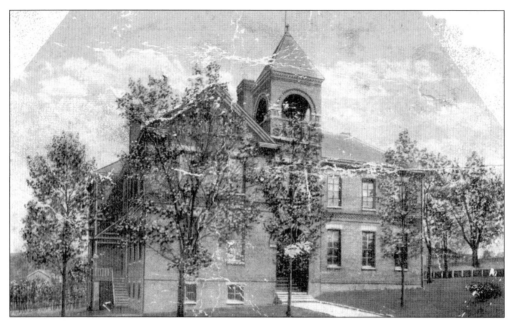

The Roby Fitzgerald building on College Street was Greeneville's first public school. Built in 1894, it was originally called "the Public School" until it was renamed for Miss Roby Fitzgerald, who was one of the town's outstanding educators. In 1973, renovation began to convert the building to a senior citizen center and renamed it the Roby Fitzgerald Adult Center. This postcard depicts the building as it appeared in 1910. (Courtesy of the Roby Fitzgerald Adult Center.)

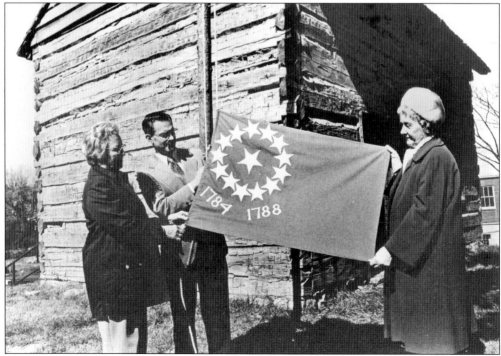

In 1976, from left to right, Mrs. Bowman, Mayor Love, and Anna Critselous present a flag at the capitol building of the *Lost State of Franklin*. (Courtesy of the Roby Fitzgerald Adult Center.)

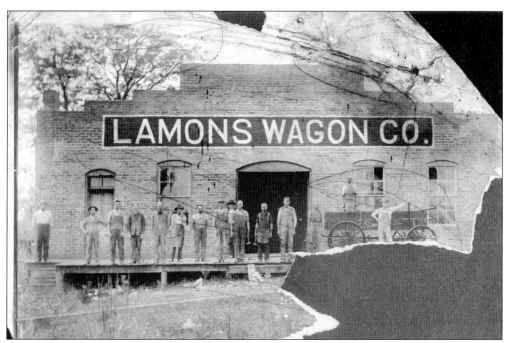

The Lamons Wagon Company, one of the earliest industries in the area, was on the corner of Floral and Irish Streets beside the railroad. Seen third from left is Charlie Colyer, who worked there prior to serving in World War I, *c.* 1916. (Courtesy of Eleanor Eacret Mosca.)

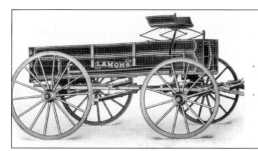

Our Standard One-Horse Wagon
BENT HEEL SHAFTS

Built in two sizes.

No.	Size of Skein	Capacity	List Price Cast Skein	Steel Skeins
10	2¼ x 7	1000	$42.00	$4.00 net extra
12	2½ x 7½	1200	$44.00	

We make one-horse wagon beds, with foot board on front. Drop gate with chain, and flare boards on side, which makes an excellent dray wagon. Price, $2.50 net extra.

Some prices are shown from a catalogue from the Lamons Wagon Company. (Courtesy of Eleanor Eacret Mosca.)

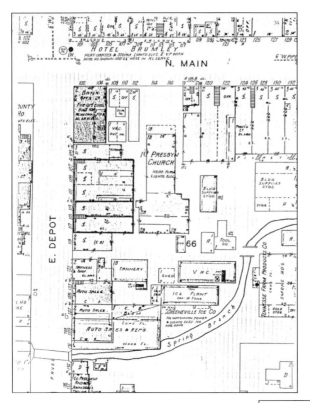

These pages from a 1929 city directory show a map and ownership of a block in downtown Greeneville. (Courtesy of the Nathanael Greene Museum.)

Doughty-Stevens Co Undertakers
Day Phone 72
Night Calls 632
Ambulance Service

CUTLER 197 DEPOT

112 Austin Tob Packing Co
109 Westmoreland R R
111 Coker J L
 (Summer Intersects)
200 Bohannon S J P Service Station
 Bohannon Storage Whse
202-204 Jeffers G W
206 Hankins C L
210 Farnsworth J M, lbr
210 McLain S H
211 Cooper Lula Miss
212 Bernard-Moore Co
213 Galbraith J W
212 Erwin Alvin
214 Cowles R S Dr
219 Davis Jennie Mrs
219 Wheatley J W
 Pierce S B
221 Miller G E
 (McKee Intersects)
300 Hope J R
301 Smith J H
 Spears W L
309 Farnsworth J M
311 Rader W N
313 Lane R F
316 Johnson B F
318 Kinsley C V
320 Snowden J D
 (Irish Intersects)
406 Murphy E A
406 Reaves Harvey
408 Smithson Thos
410 Purvis S W
—— Rader Lbr Co
DAVIS—s from 410 Maple av to Wesley
 1 w of Railroad
221 Brannan C M
224 *Montgomery Sallie
302 Richard Hubert
404 Vacant
304 (r) Cutshaw S E
—— Jones Hugh
306 Weems Kirk
308 *Henderson Frank
314 *Jones Jos
318 *Staples Jno
320 *Robinson Henry
326 *Farnsworth Jennie
327 *Patterson Lucy M, gro
328 *Carson Chauney
329 *Farnsworth Henry

329 *Fraternity Hall
333 Vacant
334 *Durham Ella
335 *Houston Fannie
DEPOT—e and w from 100 n Main one
 of the principal business streets of
 the city, and the dividing line for
 streets running north and south.
 ▶ Going East
102 Greene County Bank Bldg
ROOMS—
 1 Pierce Loan Co (The)
 2-3-4 Swingle & Hardin, attys
 7 Mathes G F, dentist
 Lunsford E C, dentist
 8 Hawkins G E, optometrist
 ▶ East Depot Continued
103 Ren-Bow Cafe
105 Vacant
107 Vacant
109 Vacant
110 City Hall (basement)
111 Ellenberry J E, clo
113 Grand Billiard Parlor No 1
115 Rima J S & Sons, tigners
116 Greene County Jail
117 Greeneville Tannery
121 Hull Bros, wagon mnfrs
123 Hail Motor Co
127 Cowles R S, phys
 County Dept of Health
129 Andrew Johnson Tailor Shop
 (College Intersects)
201 Kerbaugh A J
203 Waldrop L D
300 Looney W H
308 Vacant
 ▶ Going West
100 Mason's Corner, cigars etc
102 Mason D P
102 Cox T M, shoe reprs
103 McLain S H
104 Citizens Savings Bank (The)
106 Thompson W H, men's furns
108 Central Drug Co
110 Palace Barber Shop
110½ McDaniel R A
 Knipp Carrie Miss
 State Highway Dept
111 Castell-Wheately Plmbg & Elec
 Co
 Jenkins A H

Asheville, N. C.
Spartanburg, S. C.
Cecil's Business Colleges

Business Training Insures Business Success — Competent Office Help Furnished

F—7

114

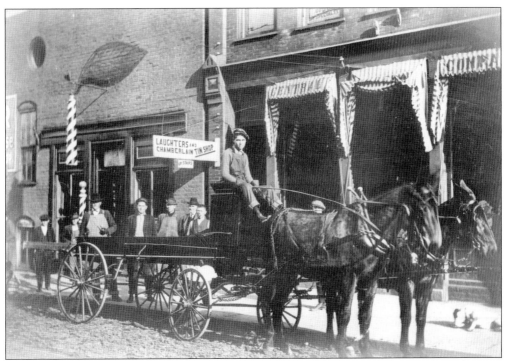

A mule-drawn cart is seen in downtown Greeneville being driven by Carl Chamberlain. This 1913 photograph was taken in front of Laughters and Chamberlain Tin Shop. Also in the background is the Central Tobacco Company, which was there for only a short time. The Banner Tobacco warehouse was bought by W. C. Waddell, W. R. Lowry, and R. C. Bird Sr. Former chief of police Marion Laughters is in the apron, foreground, and Gene Chamberlain Sr. is to his left. Others in the picture are Tom Leming, W. R. Lowry, and Charles Hull. (Courtesy of Mrs. Chris Saville.)

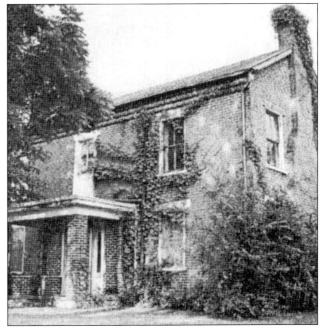

Until 2000, this home was a familiar site on the Andrew Johnson Highway at Rufe Taylor Road. Wayside was built in 1840 and was purchased in the 1850s by Mr. Abram Sevier Johnson. At that time, the property contained 600 acres. In 1889, the home was purchased by the Rufus Taylor family and remained in that family until it was razed. During the Johnson family's ownership, great pains were taken to completely furnish the home. Mrs. Johnson did not want to risk spoiling the pristine décor, thus they never occupied the house. (Courtesy of Elizabeth Duggins.)

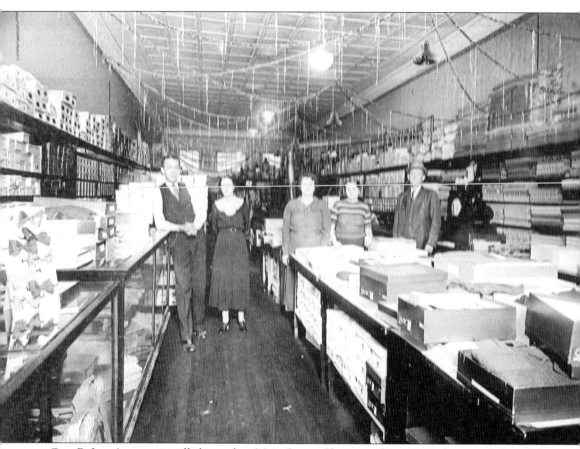

Geo. R. Lane's was originally located on Main Street. Shown in this c. 1929 photograph from left to right are George R. Lane, Fannie Bales, Mrs. Bob "Bessie" Lane, Mabel Roberts, and Charles Wayland. Mabel worked at the store from her high school days until the store closed. After J. C. Penney arrived in town, the store relocated to Depot Street. Items sold in the store included men's and women's clothing, shoes, and fabric. (Courtesy of Howard O. "Buddy" Lane.)

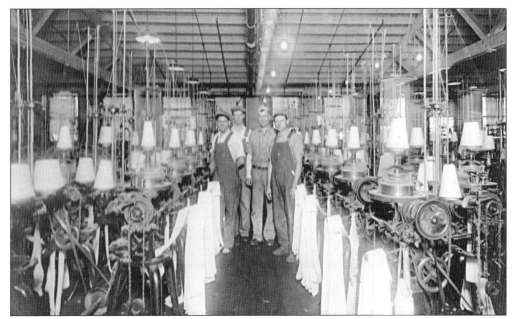

Walter Frederick "Jim" Colyer worked at the Charles H. Bacon Hosiery Mill before he served in World War II. This mid-1930s picture shows "Jim," second from left, posing with coworkers. The mill was located across the railroad track from the Lamons Wagon Company. It has been told that the mill was guarded by geese—you couldn't get near the facility without the geese making an abundance of noise. (Courtesy Eleanor Eacret Mosca.)

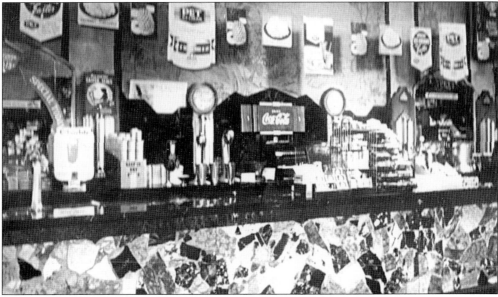

This 1940s photograph shows one of Greeneville's favorite hangouts of the time. The F&P Drug Store was owned and operated by pharmacists Tom Finch and Allen Pierce. In addition to filling prescriptions, everyone was made to feel welcome. The popular menu of fountain sodas, milkshakes, sandwiches, and the like were served to many youngsters who made a point of stopping by after school. Even at a nickel, fountain drinks were a real luxury for teens. (Courtesy of Mr. and Mrs. Robert Smith.)

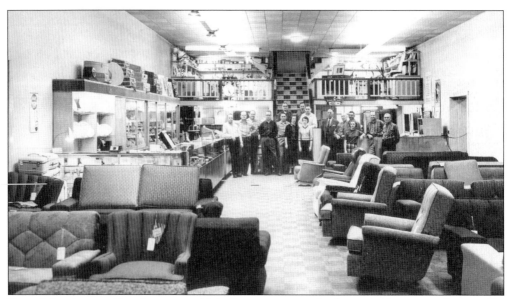

Brown's furniture and jewelry store on Main Street was a popular fixture in downtown Greeneville. This 1953 photograph shows, from left to right, (first row) Bill Kennon, Edward Roberts, Gene Sweeten, George Kennon, Willis Harmon, Jo Ann Ruder, Patsy Smith, Walter Brown, Cubert Harrison, Roy Wester, Ann Huntsman, Billy Brumley, and Drew Keasling; (second row) Charles Linebarger, R. J. Pierce, and Charles Keasling. The three-level store carried furniture, carpet, appliances, jewelry, and more. Their warehouse was at the corner of Irish and Depot Streets. Patsy Smith worked there for 30 years and recalled what a wonderful boss the owner, Walter Brown, was. Brown's opened around 1930 and closed in 1984. (Courtesy of Mr. and Mrs. Robert Smith.)

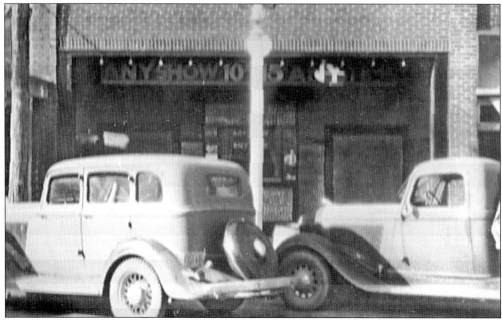

The 1934 automobiles parked outside the old Palace Theater on Depot Street date this photograph. It has been a long time since kids could see a movie for 10¢, adults for 15¢. The Palace stopped operating around 1960. (Courtesy of Mr. and Mrs. Robert Smith.)

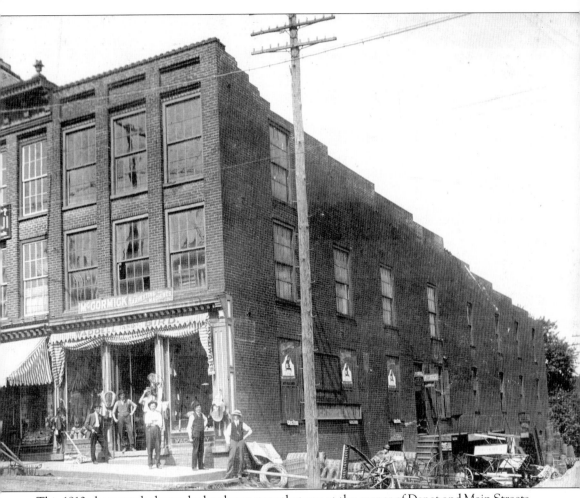

This 1910 photograph shows the hardware store that was at the corner of Depot and Main Streets. Note the steps to the side opening and machinery all over Depot Street. The gentlemen in front of the store include R. C. Bird, Robert Rankin, W. K. Mitchell, and W. C. Waddell Sr. W. C. Waddell Jr. is on the mowing machine at right. (Courtesy of Mrs. Chris Saville.)

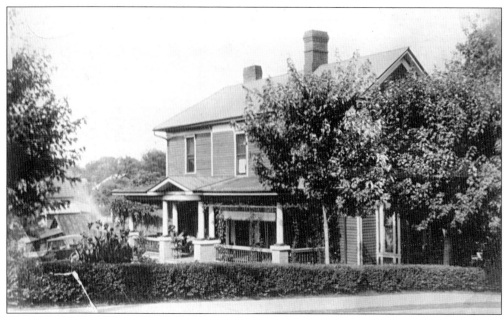

W. C. Waddell and his wife, Katherine Connor, raised their family in this house on Church Street. Their daughter, Elizabeth, recalls living there for 36 years before moving to the "country," Tusculum. The house was built in 1880. This photograph was taken in the 1940s. (Courtesy of Mrs. Chris Saville.)

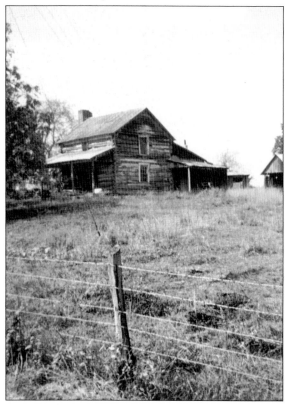

Earl and Rhoda Baskett had three children while living in this log house on the Baskett farm in Clear Springs. The house had one large room, a kitchen, a dining room, and a loft. Rhoda was known to have said this was the happiest time of her life. (Courtesy of Frances Million.)

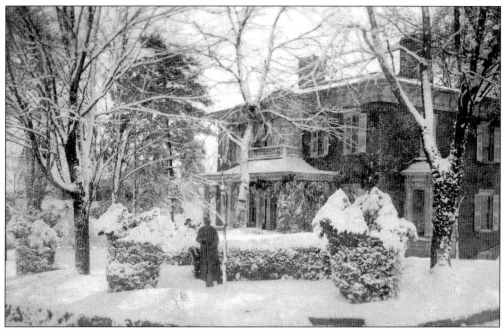

Boxwood Manor was the home of Bessie Brown Milligan on South Main Street. An unusually heavy snow had fallen for this early-20th-century photograph. (Courtesy of Mrs. Chris Saville.)

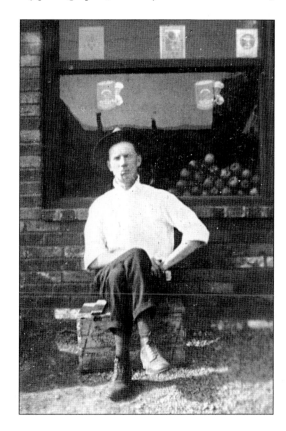

Charlie Colyer ran a grocery store on Depot Street at one time. This c. 1920 photograph was taken after he returned from World War I. (Courtesy of Eleanor Eacret Mosca.)

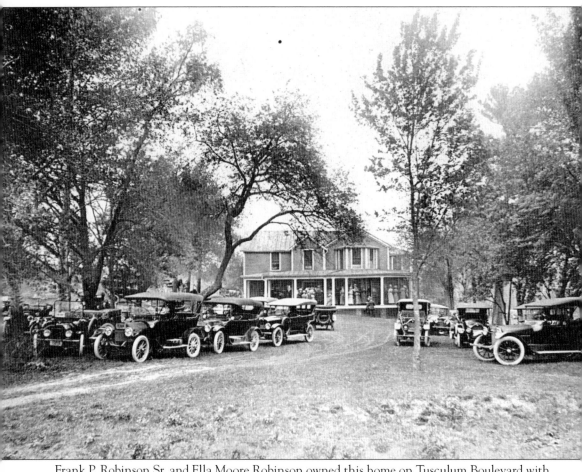

Frank P. Robinson Sr. and Ella Moore Robinson owned this home on Tusculum Boulevard with 300 acres stretching from east of the present-day Justis Drive to the Mount Bethel Cemetery (behind the current Eastgate Shopping Center). It stood where the Commons Shopping Center is currently. The house was originally built as a log house around 1780 and was remodeled several times throughout the years. This scene in 1916 is of the wedding of their daughter, Eunice, to Lyle C. Willis. (Courtesy of Louise Orr.)

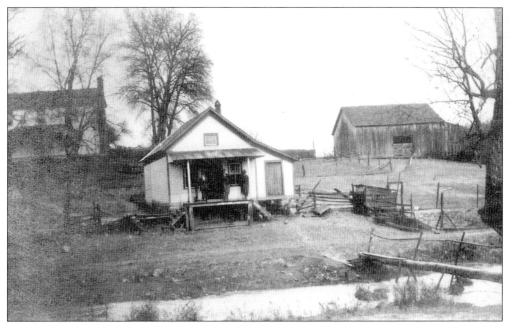

From the late 19th century until the early 1930s, Minnie and Joe White owned White's Country Store. Minnie ran the store while Joe ran White's Mill. They lived in the house in the left background with their five children. The view is from across Holley Creek near the old road and the old Pevine logging railroad. Notice the footbridge made of logs crossing the creek to the store and home. The photograph was taken in the early 1920s. (Courtesy of Mr. and Mrs. Bill Alexander.)

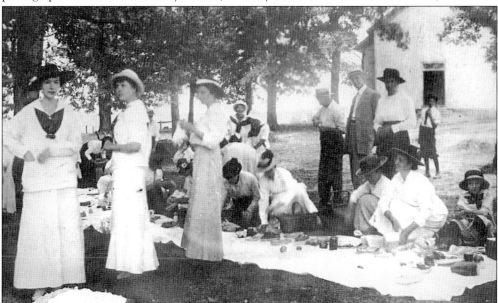

Around 1920, this dinner on the grounds was a common scene at the Shiloh Cumberland Presbyterian Church, in the background. Note the ladies in their Sunday best along with the starched white tablecloths on the ground. Edith White Alexander is seen on the far left, and Sam Alexander is in the suit, standing to the right. Their son, Bill, recalls helping dig out under the church during a renovation to make space for classrooms. (Courtesy of Mr. and Mrs. Bill Alexander.)

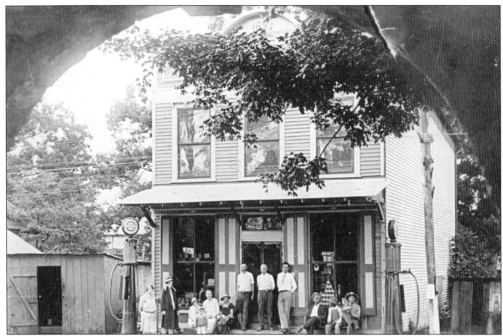

Dobson's Grocery was established in 1892 by George and Myrtle Dobson. This is the way the store appeared in 1925. Seen in front of the store from left to right are Myrtle Dobson, Grace Dobson Baskette, unidentified, Harold Dobson, Mrs. S. R. Dobson, Ethel Baskette, George Dobson, S. R. Dobson, Bill Dobson, O. B. Baskette Sr., Bill Brown, and Dan Morrow. (Courtesy of Mrs. Harold Dobson.)

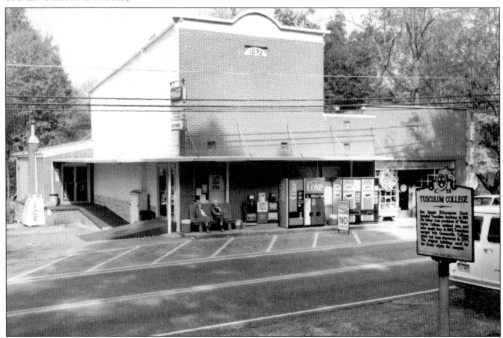

Dobson's Grocery was quite a fixture in the Tusculum community. This is how the store appeared after a remodeling in 1953. (Courtesy of Mrs. Harold Dobson.)

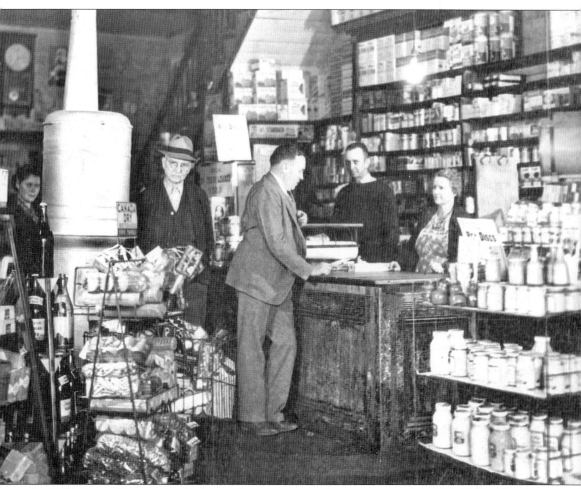

Inside Dobson's Grocery, one could purchase just about whatever was needed. This 1940s picture finds George and Myrtle Dobson behind the counter. Dr. Jim Campbell is in front of the counter while Sam "Shot" Dobson, George's father, is making sure things are in order. (Courtesy of Mrs. Harold Dobson.)

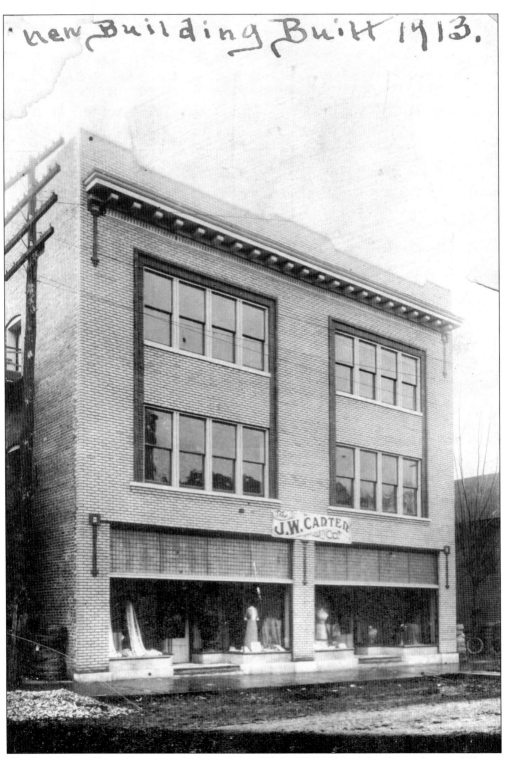

This building on Depot Street was built in 1913 by W. C. Waddell Sr. It has housed many different businesses over the years. (Courtesy of Mrs. Chris Saville.)

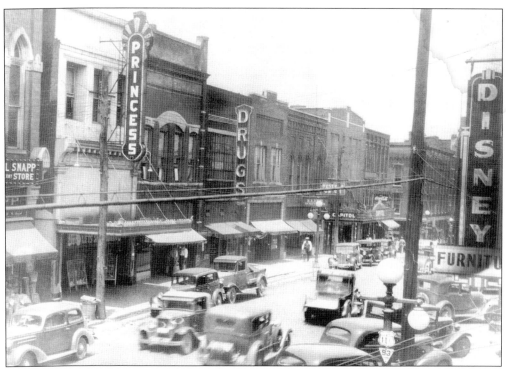

This Main Street photograph is a popular downtown image from the late 1920s. Buddy Lane recalls being in the Princess Theater on one occasion when the lights went out. He and his friends ventured outside to find a nearby warehouse going up in flames. After all the commotion subsided, they went back to finish viewing the movie. (Courtesy of Howard O. "Buddy" Lane.)

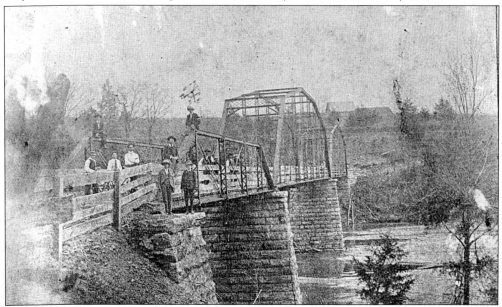

Brown's Bridge was the first bridge built over the Nolichuckey River. This c. 1900 photograph shows Will Simpson sitting on the bridge, in the center of the picture, during the opening of the bridge. (Courtesy of Mr. and Mrs. William King Gaut.)

ABOUT THE AUTHOR

Matilda B. Green received her bachelor of science degree in education from the University of Tennessee. She has taught in Virginia, Maryland, and Tennessee. She was in the real estate industry for 23 years, specializing in commercial, industrial, and investment properties while owning her own property management company. Being the daughter of an army officer, she was able to travel to and live in many interesting places. This combination of experiences has given her the ability to appreciate history and the many interesting people she has encountered along the way. Matilda lives in Greeneville with her two children, Elizabeth and Frank. She is active in the community, serving on the board of directors of several organizations. Although she has lived in the Greeneville area for just a few years, she has had family connections there for over 35 years.

BIBLIOGRAPHY

Cox, T. Elmer. *Pocket Note History of Greene County, Tennessee.* Greeneville: Teague Printing Company, 1998.

Doughty, Richard Harrison. *Greeneville: 100 Year Portrait, 1775–1875.* Kingsport: The Kingsport Press, 1974.

Greene County History Book Committee. *Historic Greene County, Tennessee and its People, 1783–1992.* Waynesville, NC: Don Mills, Inc., 1992.